The Eagle has Two Faces

The Eagle has Two Faces

Journeys through Byzantine Europe

ALEX BILLINIS

AuthorHouse™
1663 Liberty Drive
Bloomington, IN 47403
www.authorhouse.com
Phone: 1-800-839-8640

© *2011 by Alex Billinis. All rights reserved.*

No part of this book may be reproduced, stored in a retrieval system, or transmitted by any means without the written permission of the author.

First published by AuthorHouse 05/27/2011

ISBN: 978-1-4567-7870-5 (sc)
ISBN: 978-1-4567-7871-2 (ebk)

Printed in the United States of America

Any people depicted in stock imagery provided by Thinkstock are models, and such images are being used for illustrative purposes only.
Certain stock imagery © Thinkstock.

This book is printed on acid-free paper.

Because of the dynamic nature of the Internet, any web addresses or links contained in this book may have changed since publication and may no longer be valid. The views expressed in this work are solely those of the author and do not necessarily reflect the views of the publisher, and the publisher hereby disclaims any responsibility for them.

Contents

Before Reading:	A Note on Geography and Architecture	3
Prologue:	A House in Serbia	7
Chapter I:	Diaspora is to be and not to be	13
Chapter II:	Italian Enclaves	21
Chapter III:	Mystra, Byzantium's Indian Summer, and the Morea	27
Chapter IV:	Athens, The Dense City	39
Chapter V:	Salonika: The Perpetual Second City	45
Chapter VI:	Macedonia: A Region, and a Reality	53
Chapter VII:	Bulgaria, the Deep Balkans	67
Chapter VIII:	Thracian Impressions, the Edge of Greece	77
Chapter IX:	Romania in Parts	85
Chapter X:	Austrobyzantinism: Vojvodina	95
Chapter XI:	Belgrade: Byzantium's Gate	109
Chapter XII:	Smederevo and the Heart of Serbia	115
Chapter XIII:	"To the City" of the Tsars	123
Chapter XIV:	Pontus, Sacrificial Lamb of Byzantium	133
Appendix:	Brief Historical Perspective	143
Bibliography		151

12-9-2016
To Will.
An inspirational writer and individual
Alexander Billinis

To the late John Alexander Billinis, and to his grandson, my son, John Alexander Billinis.

First thanks goes to my life love and partner, my wife, Vilma, whose influence and inspiration fills these pages, in particular the architectural subtleties. To my daughter Helena, whose bright blue eyes always brought happiness through the arduous process of editing.

My big sister Barbara, always the intellectual and academic, who found time to edit, to assist, to critique, to design, and to inspire. She helped to bring a semblance of coherence to my stream of consciousness.

There are many people who contributed their ideas, or their far greater facility in eloquence and photos who deserve mention herein. I refer specifically to Mr. Milan (Jofke) Jovanovic, a distinguished Sombor artist and designer, for his work on my cover, interior maps, and in enhancing the graphics of this book. For their generous contribution of photos I thank Mr. Stratos Safioleas of Athens, Greece, and Mr. George Dratelis of Boston, Massachusetts. While I am thanking people for photos, I should also add my seven-year-old son, John, for his contributions.

I also would like to acknowledge the Greek Community of Salt Lake City, my hometown, which, along with my parents and yearly trips to Greece, instilled a lifelong Hellenism and Byzantinism, without which this book would never have been written.

Finally, there is the lovely city of Sombor, Serbia's westernmost city, where this book begins, which gave me my wife, and in whose Austro-Byzantine embrace of cafés, ateliers, and in our cozy house, provided the setting for the final editing of this work.

Before Reading:
A Note on Geography and Architecture

Geography: the Balkans

At the turn of the previous millennium, Byzantium experienced its apogee, with temporal and spiritual control over the entire Balkan and Asia Minor peninsulas, as well as deep enclaves in Italy and on the north coast of the Black Sea. These two great peninsulas were like two blades of a propeller, the center of which was Constantinople, the greatest city in the European-Mediterranean world.

The Ottoman Turks, who effectively replaced the Byzantine Empire and who adopted many of its institutions, but at the same time, relegated the Byzantines to second-class status, appropriated much of this same space. Around the fringes of this world, on its Western edges, a modernizing Western Europe held territorial enclaves, windows on a world out of reach to the Byzantines under Ottoman rule. This wish to "re-join" the West encouraged the formation of a substantial Balkan Diaspora, a phenomenon that continues to this day, and my own identity is as a Diaspora Greek is a result of this phenomenon. Further, most of the same conditions—corruption, economic mismanagement, and a "civic deficit" remain to this day, as strong as ever. This condition perpetuates the Diaspora exodus.

For well over four centuries the Ottomans held the Balkans and Asia Minor in a grip both brutal and lax, corrupt and neglected. Parts of the post Byzantine world managed to throw off Turkish rule, often with Western help, but the Turks held firm to Asia Minor, and evicted the Byzantine populations from these lands where they lived for thousands of years.

My journey is through the successor states of Byzantium, and as a fact of geography, essentially it is in large measure limited to the Balkan peninsula, where several Orthodox states descending from Byzantium

live out a complicated existence. Asia Minor was once the heartland of Byzantium, but it is now its necropolis, inhabited either by the ghosts of the Byzantines or by their Islamicized successors. That said, my journey by necessity includes Constantinople, both for its past, and most certainly, for its emerging present, hegemonic role.

Like any journey, mine is not comprehensive. It is a mixed itinerary, a photo snapshot, and a part seeking to describe the whole. Like any explanation, it is not fully accurate. Rather, it is meant to show the impressions of one who seeks to understand his roots and to come to terms with the circular history of the land whence he came. Impressions, however flawed, are mine, except when duly attributed to others.

Architecture:
Focus on Religious Buildings, and Bad City Planning

I am an Orthodox Christian, a relatively observant though not a dogmatic one. Much of my travels will center on various churches (and mosques), their architectural styles, and their wider "crowd symbol"[1*] meaning to the surrounding people. This is not meant as a plug for Orthodoxy, or an attempt to impart a strong piety where it might not exist.

My reason is altogether different. In an area where one's titular religious identity often—in the past as well as in the present—determined one's ethnic and political identity, religious buildings serve as very potent and relevant reference points, as much today as yesterday.

Even the architectural style of the religious buildings may have subtle, or not so subtle, meaning. We will see this in particular in the ex-Communist countries of the Balkans, and particularly those parts of Romania and Serbia that were once under Austro-Hungarian rule and absorbed much of their Western culture and norms. Finally, the monastic retreats, often fortresses in themselves, served as the artistic and intellectual havens for Byzantine identity during the darkness of Turkish rule and the dislocations of Communism and the post-Communist transition. As such, monasteries also merit some review.

[1] "Crowd Symbol" is a term I came across reading Robert D. Kaplan's book Balkan Ghosts. A "Crowd Symbol" is a psychological reference point for a nation. Kaplan borrows this concept from Elias Canetti, a Bulgarian-born Nobel laureate. See Robert D. Kaplan, Balkan Ghosts, (New York: St. Martin's Press, 1995) 15.

Then, we come to infrastructure, or the general lack of it. The Balkan Peninsula is the least developed part of Europe; neither the Ottomans nor their successors invested much in the creation of physical and civic infrastructure. The same goes for cities and towns. Most are either very old, owing to a Roman or Byzantine foundation, or very new, and often not very nice. Here too the entire region boasts a remarkable uniformity, regardless of the change in climate or country. The exceptions are generally those areas of the Balkans that were under a prolonged period of Austro-Hungarian or Venetian control. We begin our journey in Sombor, one such exception, in Serbia's Austrian-influenced Vojvodina province.

One Final Note

The reader may wish to start with, or refer to liberally, the appendix herein, which provides a brief historical perspective, the last 1000 years in the Balkans. I do not excessively focus on the grandeur or the sumptuous, and, even by modern terms, rather advanced civilization of Byzantium. Other greater minds and pens have done her magnificence a degree of the justice she deserves.

Alex Billinis

JOURNEY MAP

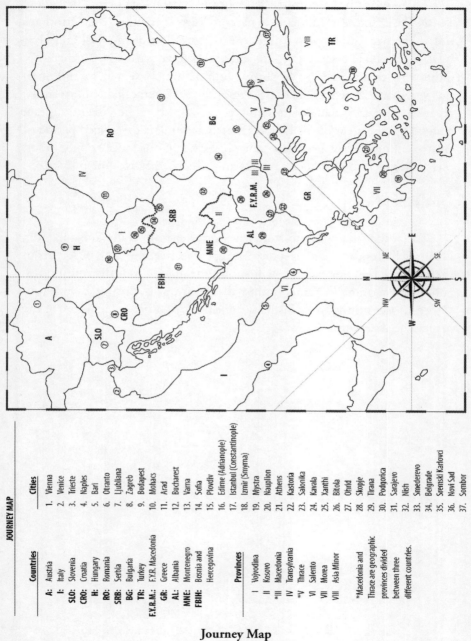

Countries
- A: Austria
- I: Italy
- SLO: Slovenia
- CRO: Croatia
- H: Hungary
- RO: Romania
- SRB: Serbia
- BG: Bulgaria
- TR: Turkey
- F.Y.R.M.: F.Y.R. Macedonia
- GR: Greece
- AL: Albania
- MNE: Montenegro
- FBIH: Bosnia and Hercegovina

Provinces
- I Vojvodina
- II Kosovo
- *III Macedonia
- IV Transylvania
- *V Thrace
- VI Salento
- VII Morea
- VIII Asia Minor

*Macedonia and Thrace are geographic provinces divided between three different countries.

Cities
1. Vienna
2. Venice
3. Trieste
4. Naples
5. Bari
6. Otranto
7. Ljubljana
8. Zagreb
9. Budapest
10. Mohacs
11. Arad
12. Bucharest
13. Varna
14. Sofia
15. Plovdiv
16. Edirne (Adrianople)
17. Istanbul (Constantinople)
18. Izmir (Smyrna)
19. Mystra
20. Nauplion
21. Athens
22. Kastoria
23. Salonika
24. Kavala
25. Xanthi
26. Bitola
27. Ohrid
28. Skopje
29. Tirana
30. Podgorica
31. Sarajevo
32. Nish
33. Smederevo
34. Belgrade
35. Sremski Karlovci
36. Novi Sad
37. Sombor

Journey Map

Prologue

A House in Serbia

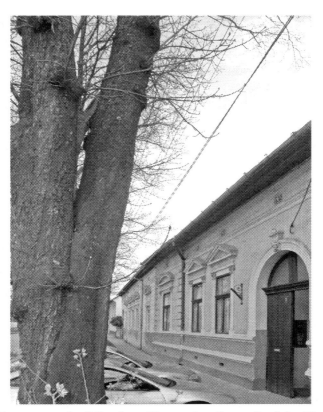

House typical of Sombor. Known locally as *Svabske Kuce* (Swabian (German) Houses), such town houses are ubiquitous wherever the Austro-Hungarian Empire held sway. Photo by Alexander Billinis.

While negotiating hairpin turns on a Greek coastal road, the cell phone rang, the second call in as many minutes. "Our offer has been accepted," she said. Anxious to avoid an accident, I swerved onto the shoulder, pulled up the handbrake, and sighed.

I had not seen the house we now committed to buy, but I trusted my wife, an architect, to make right decision. It was, after all, her hometown. Further, our tastes coincided.

We purchased a town house typical of many cities in the former Austro-Hungarian Empire, with a carriage entrance, a large interior garden, elegant moldings within and without, high ceilings and peaked, tile-shingled roof. Cool in summer and warm in winter, these houses are well suited to the environment and can be found throughout Serbia's northern province of Vojvodina. The house's foundations were set 100 years ago, in 1907, when Sombor was known as the City of Zombor in the Kingdom of Hungary, whose King also was the Austrian Emperor. Then as now, Serbs and Hungarians were the town's largest ethnic groups, but Germans and Jews were large minorities now largely vanished from the townscape as a result of the Second World War and its aftermath.

Sombor had been a substantial city in the Austrian (later Austro-Hungarian) Empire, and its architecture reflects several epochs of Austrian civic and residential architecture, from Baroque, Rococo, to Secessionist. Most of the larger homes, however, conformed to the architectural style of our new house, known locally as a *Svabska Kuca* (Swabian [German] House).

When I went to the official contract signing for the house, we learned a bit more about the ownership of the house. The first owner was a Jewish resident of Sombor, who sold to the Hungarian family who owned it until we came along. The house's carriage entrance, the *Ajnfurt*, a local Serbian corruption of the German word *Einfahrt* (entrance), is shared with another home, whose late owner was a grand lady, a local Serbian architect. The lawyer closing the transaction was a Serb of part Greek and Bulgarian ancestry. As for the buyers, my wife is a local Sombor girl of Serbian, Hungarian and Croatian background who emigrated to America, became a citizen of the US, married a Greek-American, and lived, at the time, in Greece, with a Greek residence permit due to her husband's Greek citizenship. It sounds like the lineup for an ethnic joke, but somehow in Sombor this cosmopolitan mixture fits well with the local environment. We then recorded the transaction in the City Hall, a masterpiece of late

Austro-Hungarian civic architecture, recalling a time when Sombor was an important administrative center in the Austro-Hungarian Empire.

Since my first visit to Sombor, in the summer of 2002, my mind had fixated on these houses. Built to last and spacious, they seemed to me the timeless definition of home. They incorporate all elements of proper and functional living, with large space available for work, play, kitchen gardens, and storage. In a world that has gone into an overdrive of change, these homes are built for the ages. Perhaps, too, having uprooted myself from my birth home, in Salt Lake City, Utah, in the Western United States, and moved from apartment to apartment in many different cities and countries, the seeming permanence of such a house in an impermanent, unsustainable world could not help but attract.

Were Sombor to find itself in America, or in a country with a more favorable recent history than Serbia, it surely would be an artists' colony, or a college town. It combines a human scale with an architectural treasure trove; one can trace three centuries of Austrian Empire architecture combined with assorted Socialist Realism structures of a more recent era. The Serbs call it *Zelen Grad*, Green City, and its boosters boast that it is the second greenest city in the world, after Washington D.C. I have lived for many years in the Washington D.C. area, and while I cannot determine which city is the greenest, certainly both are blessed with oxygen and beautiful foliage. The American connection to Sombor's greenery is also quite interesting. Seeking to protect the town from dust of surrounding agricultural lands, the city fathers imported tall American trees from the Mississippi Valley, which stand sentinel along all major thoroughfares, including our street. Therefore, anytime I want to meet a fellow transplanted American, I have only to go outside our gate, and onto the street!

Sombor possess the feel, similar to other towns of the former Austro-Hungarian realm, and of the former Yugoslavia, of a past greatness and the melancholy of present reality. It was a major Austro-Hungarian administrative center, larger than other current Vojvodinan cities, one that received its Royal Charter from Austrian Empress Maria Theresa in 1749, after continuous lobbying from Sombor citizens of all faiths. *Somborci* (Sombor citizens) will point to this charter, and to their efforts to secure it, as testimony to their civic mindedness, as well as their multi-ethnic toleration. A depth of civic pride exits here that you expect to find in larger cities, but is actually rare anywhere. The current relative obscurity

of Sombor is a source of resentment for locals, but also cultivates a rich nostalgia in their past, and in the arts.

While Sombor looks like a typical Austrian town, its heart beats to a southern rhythm. Possessing the haphazard charm of the Balkans, cafés proliferate in its squares, or in sultry and secretive corners, or intimate inner courtyards, catering to a clientele of considerable diversity given the city's small population of less than 70,000. Here too is the juxtaposing of Sombor's collective cultures, the Serbian, a product of Byzantine and Ottoman legacies, and the Hapsburg. All of these influences are strong in the café arena, and thus Sombor's café culture will provide examples of all. Then too, the prevailing cultural norm will vary with the season. In summer, the Balkan-Mediterranean is in the ascendant, with awnings, lounge seats, music, and water misters straight off of the Greek coasts so beloved of Serbian tourists, whereas in winter and cooler months, a more Hapsburg-Slavic theme takes over, with stronger drinks, deeper crèmes on the coffee, more intimate music, thick (and ubiquitous) tobacco smoke, and lively intellectual discourse typical of the Viennese or Budapester establishments.

The slower pace of life, and the profuse studying habits typical of the region, reinforced by Communism, results in a very well-educated population possessing a range of skills and talents beyond the town's size, and this results in more than a fair share of galleries, concerts, and exhibitions, as well as an increasing number of emigrants to the West. Personally I can think of no better place to write than in Sombor, or my on father's native island, Hydra, in Greece. Both places, ironically, had their period of greatness nearly two hundred years ago, but have preserved their legacy in elegant architecture, and in a brooding nostalgia for the "good old days" in times past. Perhaps a bit of sadness, and the architectural preservation resulting from a lack of "progress," are key elements for artistic expression.

Sombor's intellectual and aesthetic feel, and its subconscious brooding, masks the reality that it is a hard working city surrounded by some of Europe's most fertile farmland. The *Crnozemlja* (Black Earth) of Vojvodina produces a breadbasket readily capable of feeding much of the Balkan Peninsula. In late summer, the central market is an almost psychedelic whirl of color, from peppers, to flowers, to the full cornucopia of food, fuzzy in the muggy air. Most *Somborci* possess some land, using it either as their livelihood or, more often, as a sensible supplement to their kitchens and pocketbooks. Gardens groan under the tastiest produce imaginable.

Hardy, self-sufficient towns like Sombor and the agricultural plenty of Vojvodina explain how Serbia survived years of sanctions in the 1990s without giving in or suffering major social unrest. This quiet confidence in their ability to survive impressed me, and may yet be an important skill in a world increasingly beset by economic turmoil and climate change.

Sombor is diverse, tolerant, and on balance quite Western in its atmosphere. Even the long-established Serbs here will talk about themselves as distinct from other Serbs further south. They are part of a venerable community with roots, rights, and responsibilities dating back to the reconquest of the region from the Turks, where Serbian arms played a key role.

After the guns fell silent, their hands were needed to till the fields, to develop commerce, and to guard the frontier against Turkish counterattacks. The Serbs did so, on condition that their community and their church remained free from Catholic interference. In exchange, they became loyal, increasingly prosperous citizens of the Austrian Empire, and their norms shifted from Byzantine to Hapsburg. Rather than the Byzantine style elsewhere associated with Orthodox Churches, Sombor's Orthodox Churches are baroque, with cupolas and outward structure no different than neighboring Catholic Churches.[2]

The Sombor Serbs' assimilation of Austrian culture was in some ways similar to a Diaspora experience. They were part of the Serbian nation, but not part of Serbia. Uniquely in the Orthodox world, the Serbs of Vojvodina experienced the full development of European culture, while remaining true to their traditions. Geographically, they were not far separated from the core of Serbia, yet their mentality and culture were transformed by the Austrian experience. These Serbs did not return to their homeland, instead, their homeland incorporated them by conquest. When Yugoslavia was formed, Sombor's Serbs both rejoiced and at the same time felt a sense of loss for the old Hapsburg Empire that had provided economic and social opportunities Serbia-Yugoslavia could not. They did, however, prosper in postwar Yugoslavia, and the Yugoslav regime's multi-ethnicity fit well with Sombor's—and Vojvodina's—traditions of tolerance. After all, two dozen nationalities lived in the province. The local Serbs' almost

[2] More recent churches in Vojvodina, as we shall see, conform to Byzantine architectural norms. This is in large part an effort to reemphasize, to Serbs and to others, the Orthodox Byzantine roots of the Serbian nation. See the photos on the following page.

Diaspora mentality was one I understood very well as a Diaspora Greek, and is perhaps another reason for my deep attraction to the area.

For our family, Sombor serves as our center of gravity; it is also a convenient place to start our journey. It is a bit of a stretch to consider Sombor part of the Byzantine world through which we will travel, except that it is a constituent part of Serbia, which certainly is Byzantine. Vojvodina is a blended world of Byzantium and the West, with the West in the architectural and normative ascendance in Sombor. It is this ready mix of cultures and contrasts that make Sombor a good place to start the journey. Byzantium's complicated relationship with the West, and the whole "Diaspora" relationship with the Byzantine motherlands, is palpable here. It also makes sense that our first chapter after this Sombor prologue discusses the concept of Diaspora so crucial to the Balkan reality.

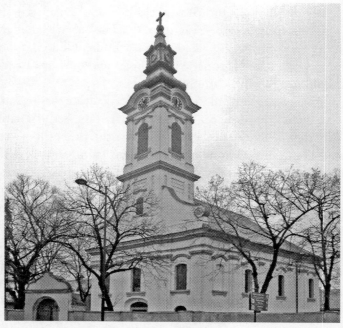

St. John the Forerunner Serbian Orthodox Church, Sombor. My daughter was baptized here, and the small, exquisite church is typical of Serbian sacred architecture in Vojvodina, where Western styles predominated until very recently. Photo by Alexander Billinis.

Chapter I

Diaspora is to be and not to be.

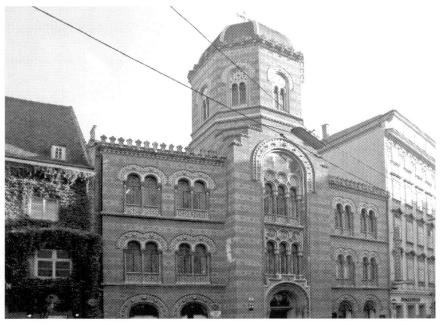

The Greek Orthodox Cathedral and Community center of Vienna, whose present façade dates from the early 1800s and it is one of the oldest and most famous churches of the Greek Diaspora. Photo by John Billinis.

Like millions of other Greeks, I was born in the Diaspora. The word itself, fittingly, comes from the Greek language, "a scattering or dispersion." For millennia Greece has been shedding population, in ancient times to Greek colonies established primarily in Italy, Asia Minor, and the Black Sea basin, and in the post-Byzantine world often to these same destinations or further west. In our era, Greeks have ventured to the far reaches of the world, North and South America, Australia, and northwestern Europe. Greece owes part of the energy of its rebirth to its Diaspora, which supplied material and physical aid to the cause. Sometimes, these Diaspora Greeks resettled in the newly emerged country, and often as not, returned to the Diaspora.

The reason for exit generally consisted of a combination of economic and political factors, and which combination depended on the era in question. Certainly Greece's grinding poverty and poor soils, coupled with constant wars and revolutions, spurred the majority of the modern exodus, though, as the population became more educated, the political and bureaucratic environment also encouraged a brain drain, as well as the peasants' brawn drain. Greece, like other Balkan countries, had its development arrested and distorted by the five centuries of corrupt Ottoman rule, a legacy that continued after independence and is still very much in evidence today. Greeks voted with their feet, and as a maritime people from time immemorial, the means to exit are readily available.

My own Diaspora origins derive from political and from economic factors. My maternal grandfather, induced by the poverty of his surroundings, left the hills above the Peloponnesian port of Patras for the railways of Utah about a century ago. He returned to fight in the Balkan Wars, but after marrying, left again for the United States, and had six children in America, including my late mother. My late father was born on the seafaring island of Hydra, the son of a sailor father from a remote Peloponnesian village and a Hydriot captain's daughter. He was raised in Pireaus, during the 1930s, when Greece was slowly industrializing but deeply shattered by the Asia Minor disaster. My father's circumstances were middle class; his sailor father visited once or twice a year as the price for his family's relative comfort. The horrors of World War Two and its aftermath took its toll on my father's psyche, and, after service in the Navy, my father took to the sea. He possessed a good education and he had every reason why he would live well in postwar Greece, but meeting

my mother in America made him part of the Diaspora, and they had three children, all born and brought up in America.

I spent nearly all of the summers of my youth in Greece. As much as I did identify with Greece, I could not really say I felt totally at home there; I often said going back was "a dream that I hope never comes true." My father sometimes thought of returning to Greece, but the politics of the country, the inefficiencies, corruption, and bureaucracy relative to life in America always stayed his hand. Cautionary tales abounded, about people who sold up in the West, and then moved back. What started as a blessed dream often became a stultifying reality.

Nonetheless, Greece continued to draw me and the Diaspora experience held me in its thrall. I had the good fortune to travel quite widely, and in nearly everywhere I visited, I found Greeks. In Santiago, Chile, at the tiny Greek Orthodox Church, I met a fellow who recognized my last name, and we found that we were distantly related. In Hungary, I met remnants of a Communist Greek Diaspora scattered around the former Communist world. Elsewhere in Europe I encountered nearly empty churches which as always function as the cores of Diaspora communities, and people who barely knew Greek, just that their background was Greek, and that mattered to them.

Nations resemble sedimentary rock formations, where layers eventually blend into the whole. So it was with the Greek Diaspora. Thus, the Orthodox Cathedral of Vienna, a church with a venerable Greek past, now hosts Austrians assimilated for generations, along with a sprinkling of new arrivals, students, or visitors. The same held for the Greek Orthodox Church of Trieste, once home to a thriving Greek community of substantial wealth and influence, and now of Italians who acknowledge their Greek descent by clinging to their church affiliation. Just around the corner, another Orthodox Church, this time Serbian, hosts a flock of Italo-Serbs as well as thousands of new arrivals fleeing the economic chaos of ex-Yugoslavia.

Sometimes the sedimentation breaks down, and the grains of sand emerge again. I have seen this when a fourth generation Greek-American discovers his roots, perhaps after a trip to the old country, and immerses himself in a country or culture he utterly wants to understand but will find that he cannot. He might even amuse locals with attempts to speak Greek in a now vanished dialect, filtered through a heavy American accent. It could be even more remote, where a Sicilian-American fellow from Ohio

converts to the Orthodoxy his distant ancestors might have celebrated, and then returns to Italy as an Orthodox bishop.

Other times, the rocks are crushed and the sands are sent forth to disparate fates. Greeks suffered ethnic slaughter and mass expulsion from their Asia Minor homelands, lands where they formed part of the ethnic mosaic. They were far more indigenous to the area than the Turks who expelled them. Other, smaller expulsions occurred, from Bulgaria, Russia, Alexandria, and finally Constantinople. Often as not, these expellees had a higher economic and cultural level than the local Greeks among whom they settled, and most chafed at their new surroundings and circumstances, the scars of which remain today.

Many of these refugees, having been uprooted once, resumed their wanderings in search of a better life. Most famous of these was a tobacco merchant's son named Aristotle Onassis. Expelled from wealthy surroundings in Smyrna and unable to accept his straightened refugee reality, Onassis left for Argentina, where he made the first of many fortunes. Many others left for France, America, or, in the next generation, for Australia, Canada, and Germany. Others, with their relatively higher education and profound sense of material loss and grievance, joined the Communist movement and after the Civil War, many fled, willingly or otherwise, into the Communist countries of Eastern Europe and the Soviet Union.

My sister's husband's family was not atypical of Asia Minor expellees. Pontic Greeks uprooted from comfortable surroundings on the southern shores of the Black Sea, to Kavala, they lived in a prefabricated home in a refugee district, with winding streets whose names often recall lost Asia Minor homelands. I remember visiting the house in the late 1970s, before it, like most of the others in the neighborhood, gave way to modern, well-appointed multistory apartments, often financed by members of the family in America, Germany, or Australia. Of the four children in my brother-in-law's family, two had immigrated to America. Other family returned to Greece after years behind the Iron Curtain as Communist refugees. Still other, more distant relatives, had lived in Russia for centuries, and now "returned" to their nominal homeland, Greece.

My own "repatriation"[3] was voluntary, as a senior banker. I possessed a Greek passport, a fluent though flawed facility in Greek, exceptional

[3] "Repatriation" (Επαναπατρισμος in Greek) is a very euphemistic bureaucratic term for the set of regulations that allow every Diaspora

knowledge of Greek history, and extended family in Greece. What I lacked, aside from my passport, were the myriad of hard-to-get documents from a labyrinthine bureaucracy that runs Greeks' lives, completed military service, and property. We would go every summer to Greece in my teenage years, and my Serbian wife had a Balkan frame of reference, which I grafted onto my historical knowledge to "prepare" me for life in Greece. I found that, for one who had lived "outside," nothing really prepared you for life in Greece.

Καλημερα Ελλαδα *(Good Day Greece)*

The *Elliniki Pragmatikotita* (Greek Reality) strikes both as a fist and as a "water torture" of thousands of drips. The country operates, if at all, on connections and influence, to a degree that I simply could not fathom. Then there was the tyranny of the bureaucracy, and the constant attempt to circumvent it and to corrupt it, which created a vicious cycle. A case in point was the requirement that I go to the army for basic training, despite being 36 years old. Actually, my service in the army was a great experience; due to its short duration, I had the "tourist version" of military service. In Greece, the "Tourist Version" of nearly everything is better than the "real" version.

My unit was full of Russian-born Greeks, so much that Russian was the second language. Most of these *Rosso-Pontioi* (Russian Pontic Greeks) kept to themselves, but in some ways I identified more with them, as returnees from the Diaspora, than with local Greeks. The difference was that I returned under comfortable circumstances, with greater prospects. I was struck by the degree of alienation they felt from "their country," and their fellow Greeks.

Everyday life in Greece is a challenge. To do well seemed to presuppose beating and corrupting the system that is, itself, corrupt. I was not wired for such a life, where so many people got paid under the table, and the cost of living was high. Looking the other way, whether in work or in life,

Greek head of household to "repatriate" his or her household effects, including a car, motorcycle, or boat (one of each, please) to the homeland "tax free." This requires mountains of paperwork, often with contradictory, or unclear directions, multiple visits to government offices in Greece and your local consulate abroad, and ultimately, often as not, a more private and "unofficial" form of taxation. A Greek is allowed only one "repatriation"; one was more than enough for me.

was a way of life. I looked to the future of rising cost of living, a crapshoot healthcare and educational system, and I surmised that I had a choice: to play the game and go native and under the table, or to vote with my feet and return to my Diaspora destiny. Looking at my wife and my son, named after my late father, the choice was obvious. That was December 2007, and less than two years later, Greece began her economic freefall.[4]

So, having seen off the moving vans, saying goodbye to friends and family, we packed our car, which we brought, like ourselves, from America, and started north on Greece's spanking new autobahns for Serbia and eventually, for London. Going north, we encountered others on their way back, to Germany, Austria, the Netherlands, and elsewhere, particularly as we left Greek Macedonia and entered into the Slav Macedonian Republic. Crossing into Serbia, the road joined that from Bulgaria, where more joined the Diaspora journey north, driving loaded-down used Mercedes sporting German plates but swarthy passengers, Turkish, Albanian, or Bulgarian *Gastarbeiter*. Throughout Serbia, more cars joined the route northward, all sporting foreign plates but local faces. The whole Balkan Peninsula, it seemed, joined in the Diaspora experience, retracing in luxurious used cars routes once traveled by ox-drawn cart towards greater prosperity. Greeks and Serbs had been traveling this route in successive waves for dozens of generations, founding communities that either assimilated or survived due to influxes of new immigrants. Now a flood of Muslim Turks for the industries Western Europe swelled their ranks.

For centuries Serbia had sent her children outward, due to the same factors as Greece. Serbia had suffered the disfigurement of five centuries of Ottoman rule, like Greece, and her Diaspora also nurtured the dream of a re-born Orthodox state. When it occurred, often they returned to help run the new kingdom, while others, due to poverty and politics, left.

The Yugoslav regime's soft Communism created a Diaspora of political dissidents along with those who left for the economic opportunities in Germany, Sweden, Australia, and elsewhere. Then, the wars of Yugoslav dissolution resulted in at least 400,000 Serbs leaving the country in order to live a normal life, particularly to Canada, Germany, Austria, Australia, and America. Among them was the woman who would become my wife.

[4] After one particularly annoying visit to the local municipality, where we dealt with what passes for civil servants in Greece, my wife said, "if any country could go bankrupt, it would be Greece." This was in 2006.

When we met, in Chicago, at the Serbian Orthodox Church, she was one of thousands of well-educated Serbs who sought a better life and possibly roots in America.

As we left Serbia, continuing to London, we waved goodbye to the Balkans and returned to the Diaspora, to the way of life we both knew was our destiny. And yet, before leaving, we bought a house in Serbia, and return constantly, as to Greece. Like many Diaspora people, we cannot quite let go. The Diaspora experience is a revolving door for us. Perhaps it is our only true identity.

Chapter II
Italian Enclaves

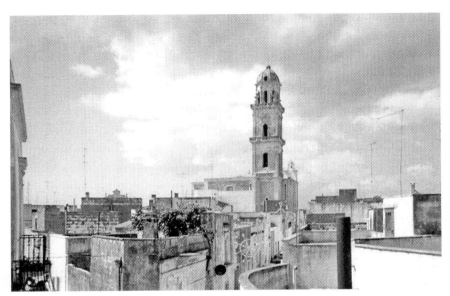

Village in Grecia Salentina, an enclave of Greek speech and culture in Salento, the Heel of Italy. Photo by Alexander Billinis.

Alex Billinis

Byzantium's presence on the Italian peninsula is old, much older than Byzantium itself. Like the Asia Minor peninsula, the Italian played a constant and crucial role in the Byzantine state and in its various successors, down to the present day. Rome is in Italy, and after all, the Byzantines were the legal and lineal successors to the Roman Empire and called themselves Romans. Others did as well, and still do. Rome was also the successor to Classical Greek civilization, so the Byzantines had every reason for feeling native to the Italian peninsula.

The Byzantines viewed the Gothic tribes who knocked out the Roman Empire in the West as interlopers and usurpers to their Roman patrimony, and Byzantine Emperor Justinian's forces, led by the brilliant General Belisarios, re-conquered Italy for the Empire in the 500s. Justinian's conquests were short lived, as other Germanic tribes succeeded in removing imperial control from most of the peninsula, though the South and enclaves throughout Italy remained loyal to Constantinople. Among these enclaves was a waterlogged group of islands in a lagoon near the mouth of the Po River.

Byzantium's political control in Italy ended in 1071, it was a bad year for the Empire. In the East, the Turks knocked out the Byzantine army at Manzikert, in the extreme east of Asia Minor, opening Anatolia to the Turks, from which they never left. In the West, the Normans captured Bari, the last Byzantine enclave, and except for a brief occupation of Ancona about 100 years later, the Byzantines never returned to Italy. At the same time, that waterlogged Adriatic outpost later to be known as Venice, came into its own. Venice emerged from being a protectorate of Byzantium, to a predator of her former imperial master, a creditor, and ultimately the site of the first Greek Diaspora. Venice I briefly visited twenty years ago, while a student on a year abroad in Budapest, but aside from St. Mark Cathedral, obviously Byzantine inspired, and the Four Horses directly flanking the Cathedral, booty from the perfidious sack of Constantinople in 1204, my tour was that of a hurried college student more driven by hormones than heart and history. Even so, Venice felt somehow familiar, both as an outpost of my Byzantine heritage, and, almost as powerfully, like an imperial capital to which I, a former subject, felt an attraction. I did not forget that my surname was most likely Venetian in origin.

About ten years after my brief Venetian visit, with a career as a Chicago banker, I began to think about this book systematically and started an online friendship with members of various organizations in Southern Italy dedicated to the preservation of the local Greek dialect, known as Griko.

This dialect is spoken in a few mountainous villages in Calabria, Italy's toe, and, more surprisingly, in about nine villages on the Salentine Peninsula, Italy's heel. Armed with a few names, addresses, locations, and a faith in Mediterranean hospitality, I packed a small bag and set off for Naples.

Naples, the Ancient Greek *Neapolis* (New City) I found to be a large, rather aggressive, dirty Mediterranean city, though the food and coffee were predictably excellent. Though many post-Byzantine Greeks immigrated to the city and various monuments and clues of their sojourn, together with those of their ancient ancestors, remain, I chose instead to decamp quickly to the Adriatic city of Bari by train.

Naples' train station felt as if I had already reached the Balkans, as a good portion of the people inside were Albanian or Montenegrin. I found my eastbound train, and began my journey across the Appenines, Italy's mountain spine. The countryside in late August was parched by the summer's accumulated three months of dry heat, but as we increased in elevation, the Mediterranean microclimates quickly went from palm to pine to alpine, and then just as quickly the process reversed. About three hours later the blue line of the Adriatic appeared. The first stop, Monopoli, with its clearly Greek name functioned as a welcome to the region. The train ground to a halt, and I helped two Italian nuns with their luggage, who, I believe, called on *La Madonna* to grant me a safe journey. We passed a series of coastal towns before arriving at Bari.

As Byzantium's last outpost in the West, Bari merited an overnight stay, and its old city with its accumulation of Byzantine, Crusader, and Venetian architecture reminded me vaguely of Corfu, with considerably less natural beauty and charm. Like Corfu on the other side of the Adriatic, Bari has an important saintly resident. I went to the Church of San Nicola di Bari to view St. Nicholas' earthly remains. As the patron saint of sailors, Saint Nicholas and the male and female versions of the name "Nicholas" are ubiquitous in Greece, and in other Orthodox countries. In a gratifying show of inter-Christian solidarity, the Crypt itself houses an Orthodox chapel, where, when I visited, two Russian monks were deep in prayer, their Slavonic cadences transporting Bari, if only briefly, back to the Byzantine bosom. Though the Crypt and the relics of Saint Nicholas moved me greatly, generally Bari left me a bit non-pulsed. It seemed a typical Mediterranean port, somewhat seedy, with only a few monuments recalling the particular Byzantine past I sought to find. I needed to head south, into Salento, to find a living link to the Byzantine past.

Italians love their cars, and their road builders obviously retain enough of the Roman engineering skill to produce some of the world's finest highways, the *autostrade*. This is a complete contrast to Greece, where until recently most roads were oriental tracks. The route from Bari to Lecce, Salento's baroque "capital," was a brisk one, and merited a stop in the shade of architecture to rival Florence, for one of my beloved espressos. Lecce is a beautiful reminder that Italy, in contrast to most of the Balkans, had a Renaissance, and the most obvious evidence of this is in architecture, though it is equally evident in the Balkans' deficit in civic culture.

Notwithstanding the moniker "Florence of the South," all of the locals and tourists seemed to be Italians, and they enjoyed their architecture with a relaxed intimacy.

The *autostrade* runs through the middle of the Italian "Heel," and only a few signs alert the driver that he is passing through *Grecia Salentina*, a small oasis of Greek language and culture in the middle of the Salentine Peninsula. Pulling off to one of them, the village of Calimera, I am greeted by the town name and "*Kalos Irtate*" the local welcome in the Griko dialect. The nine towns of Grecia Salentina, all of which I visited, were part of a larger Greek language area that receded with time, and for the most part the towns, whitewashed affairs in the midst of olive groves clustered around a baroque church bell tower, all looked the same. The colors reminded of the Greek islands, and even the church towers recalled places in Greece that had experienced Venetian rule, such as Naxos or Corfu.

Though there are a few carefully preserved Byzantine chapels dotting the countryside, the functioning churches are Catholic, and have been for centuries. Orthodoxy faded, by necessity, into the Uniate Doctrine, or *Rito Greco*, as it is known locally. This Uniate rite, using Greek in the liturgy and elements of Orthodox liturgy, was discontinued by 1600, replaced by standard Roman Catholic liturgy and doctrine. That said, some people have converted to Orthodoxy out of a sense of cultural loyalty, and in *Grecia Bovesia*, a small proportion of Greek-speakers remain Uniates. Southern Italy also has a large Albanian-speaking population, similar in culture to Greece's *Arvanites*, and often they remain staunchly Uniate or Orthodox, and culturally Byzantine. Many in fact came to Italy in the Ottoman era from parts of Greece, and the *foustanella* is often worn at their celebrations.

In the town of Corigliano d'Otranto, I fell in with a local cultural circle, the *Argalio* (Greek for "loom"), and they spun tales, in a combination of the Griko dialect, my Spanish-leaning Italian, and broken English, over

fantastic seaside meals and midnight music, where all voices joined in their songs of love and heartbreak, in a dialect readily understandable to a modern Greek. They also introduced me to their *Pizzicata* dance, a spinning dance where man circles woman circles man, and they laughed at how I danced it "like a Balkan, but I guess that's what you are, after all." Their music sounded familiar yet different, lacking the spice of the East, of Turkey, that so colors the music from Slovenia to Syria. They too lacked that bitter taste, that peppery anger, which all of the people on the Eastern side of the Adriatic seem to possess. The heavy weight of the Turkish presence was palpably absent.

For a bit more of the Balkans in Italy, I went to the town of Otranto, the where the Adriatic reaches its narrowest point. Here fortress walls, and a properly frescoed Byzantine Church greet the visitor, the only place on the Italian mainland to fall to the Turks, in 1480. Albanians were all over the town, ferry services advertised routes to Corfu, Valona, and Durres. My car radio picked up music from across the Adriatic, Albanian folk pop sounding every bit like Greek, Serbian, or Turkish music, just change the language. I could not help think that the Balkans without the Turkish legacy is not the Balkans. After all, the word "Balkan" itself is Turkish for "mountain range." It says it all.

Back in Corigliano d'Otranto, we had another evening of cafés and mini festivals. More parties were due later in the week, in neighboring towns, but I had to move on. The place captivated me too much, it was like Greece with all of the delights but without the weight. I recalled Greek Nobel Laureate Georgios Seferis' words, "Everywhere I travel, Greece wounds me." It did not here. In fact, I sensed that if I did not leave, I might just stay. The next day, I boarded a ferry from Brindisi to Patras, the Peloponnesian port where my grandfather first set out for America. My friends waved from the pier.

Chapter III

Mystra, Byzantium's Indian Summer, and the Morea

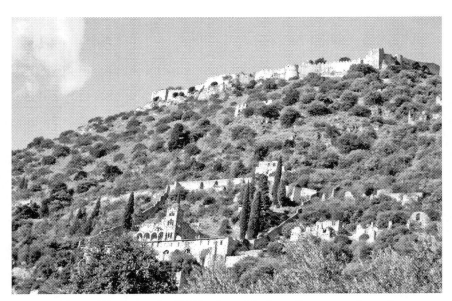

View of Mystra, the "Hill where Modern Greece was born," according to Nikos Kazantzakis and where Byzantium expired, breathing life into the Renaissance. Photo by Styve Reineck via Shutterstock.

Mystra is a relative newcomer in a land as ancient as the Morean Peninsula. The Morea (named after the Mulberry tree) though diminutive in size, birthed so much of Greek history and culture over the ages. Most people know it as the Peloponnesus, the leaf-shaped southern peninsula of Greece. The first clearly Greek civilization, the Mycenaean, centered on the Peloponnesus. Like Greeks of later ages, these Mycenaeans spread themselves over the Aegean and nearby parts of the Mediterranean, traveling, in typically Greek fashion, by ship. Much of subsequent Classical Greek culture centered on the Peloponnesus, though for much of the Roman and Byzantine era the Morea retreated into the periphery of the empire, and for most of the Byzantine period semi-assimilated Slav tribes dominated the high ground. Mystra arose as an accident of history, when the Crusaders who temporarily dismembered the Byzantine Empire sought a strategic site to dominate the Valley of Sparta.

The Peloponnesus is technically an island, occasionally referred to as the "Isle of Pelops." The Corinth Canal, completed in 1893, severs its narrow isthmus, six miles wide. This narrow canal, essentially cut through a mountain spine, is easily missed if speeding by on the new Brussels-financed autobahns, which bridge its narrow channel on high. The old bridge is the best way to see the canal, and just to the south, another work of engineering stands, much reduced. It is the Hexamillion (Six Mile) Wall, built across the isthmus on successive occasions to keep invaders out. The first wall was built in Classical Greece, during the Persian Wars. The second manifestation, commissioned by the Byzantine Emperor Justinian, designed to keep out the Slavs, failed in its task, as did the final version, repaired one thousand years later, built to keep the Turks at bay.

The Slavs' invasion of the Balkans permanently altered the demographics of Southeastern Europe. A glance at the map shows this clearly, where Slavic states cover most of the Balkans, but fewer people realize that the Slavs settled, often in depth, to the southern capes of Greece. That fact is of particular importance to the founding of Mystra. The Byzantines' Greek-speaking culture absorbed most of the Slavs south of Mount Olympus. Byzantine religious and institutional norms rooted themselves in Slavs north of Mount Olympus, who kept a Slav ethno-linguistic identity grafted onto a Byzantine cultural, institutional, and religious identity. The Morea, however, hosted Greece's remaining Slav tribes, two of whom remained un-absorbed linguistically until the coming of the Turks, one thousand years after their arrival in the area.

These wild mountain tribes resisted civilization but not Orthodoxy; when the Crusaders burst forth onto the Peloponnesian scene in 1205, the *Melingoi* and *Eziretai* resisted the Western intruders with zealous Byzantine fervor.

Mountain Worlds . . .

I have visited the high mountain worlds of these long-absorbed tribes, who lived over 1000 meters above the plains below. The *Melingoi* lived in a small mountain valley reached by age-old mountain paths or 1950s era roads with barely legal S-Curves hiking almost vertically 1200 meters up from the valley of Sparta. The village of Anavryti rises just before the next, final spur of the Tayegetos Massif. Here existed a Slav-speaking microcosm for over one thousand years, yielding to the Greek language only in the 1500s.

I arrived at a small hostel, built in a mountain style halfway between Balkan and Swiss, and took one of my ubiquitous double espressos. The barista on duty had a bit of a stilted accent more reminiscent of north Greece, and when I asked, she told me she was Bulgarian. I felt the irony, given the region's past. I then told her, in my fading Bulgarian that a Slav language related to Bulgarian was spoken here for over a millennium. She smiled politely with a look of vacant incomprehension, either my limited facility in Bulgarian did not get the point across, or she had no idea what I was saying. Patrick Leigh Fermor, Greece's great biographer who trekked these mountains (and who still lives in the Mani, on the other side of the Tayegetos Range) also commented in his inimitable book <u>Mani</u> on the "other" background of these mountain villages. Some people in the Spartan plains below claimed that the mountain people were of Jewish background, but there is no evidence to this claim, and Fermor also commented on their likely Slav descent.[5]

Southeast of the Spartan plain, on the Vatika peninsula, the mountains rise again steeply and we turned our VW Golf onto these switchbacks, rising vertically out of the small coastal plain of Neapolis, a town where my uncommon surname, Billinis, is ubiquitous. Locked in their mountain fastness, these villages also lived in their own microcosm, and here, too, lived a Slav tribe, the *Erziretai*, before assimilating into the Byzantine

[5] Patrick Leigh Fermor, <u>Mani: Travels in the Southern Peloponnesus</u>, (London: John Murray, 1958) 9.

Greek ethno-linguistic mass some time after the Turkish conquest. In one of the highest villages my grandfather, Alexander, was born, before he contemplated the poverty around him, and, like Greeks from time immemorial, took to the sea, which eventually claimed him, due to a German U-Boat, in World War Two.

One November afternoon in 2007, my wife, son and I sat sipping Turkish coffee[6] in a small room with an ancient samovar and equally venerable villagers, and we heard the story of the village and my family. We did not discuss the possible Slav origins of the villagers; we focused on the more recent Turkish legacy. Whatever the inhabitants' origins were the mountain fastness of both the Vatika and Tayegetos Massifs certainly provide a perfect refuge and staging area for small, self-contained micro-cultures.

The Founding of Mystra

The Crusaders took advantage of the disarray in Byzantium following the capture of Constantinople in 1204 to carve feudal territories in various parts of the Morea Peninsula. The Frankish knight Geoffrey Villehardouin conquered the valley of Sparta, where he built his palace, *Le Cremonie*. He had to contend with the periodic descents of the Mellingoi, who mixed a Byzantine proto-patriotism with brigandage. These Slav mountaineers' determined attacks, as the great Byzantine historian Sir Steven Runciman relates in his wonderful book The Lost Capital of Byzantium, prompted the Frankish knights to ensconce themselves on a conical hill called *Myzithra*, named after a local cheese whose piled contents the hill resembled. Using the best military architecture of the time, they built a large castle atop the hill, both as a sighting post and as a refuge against these Byzantine marauders.[7] The castle and town forming below became known as Mystra, a corruption of Myzithra. Its accidental birth could not have foreshadowed its future fame.

The alien Frankish regime in the Peloponnese was an enterprise doomed to eventual demise. Destruction and dislocation constituted the main impacts of their hundred odd years in the Morea, though their

[6] Also known as Greek Coffee in Greece, Bulgarian Coffee in Bulgaria, Serbian or "Our" Coffee in Serbia.

[7] Sir Steven Runciman, The Lost Capital of Byzantium, (London: Tauris Parke, 2009) 31.

military architecture and the foundations of Mystra are lasting, and positive legacies. With Frankish culture and Catholicism rejected by virtually all Byzantines, whether noble or serf, Greek-speaking or Slav-speaking, and inward migration wanting, demographics alone presaged the end of the experiment. In the end, even the land itself absorbed them; lacking women, they turned to the local Greek women, who subtly, with feminine grace and patience, ultimately "conquered" the conquerors.

As Kazantzakis artfully relates in Journey to the Morea:

They mingled with the women and forgot their homeland. The children emulated their mothers, they spoke the mothers' tongue, and became Greeks. The infants' Frankish blood retreated . . . A new conquest began. [8]

The revived Byzantine Empire merely had to kick in the door to reclaim their house. A battle in Macedonia sealed the fate of the Frankish principality. The Byzantine army routed the Franks on the field of Pelagonia in 1259, and to regain his freedom the Crusader Prince of Achaia, William Villehardouin, relinquished his hold on the southern Peloponnese, including his beloved Mystra and the Byzantine "Gibraltar" of Monemvasia.

The Byzantines immediately began to build a political and cultural center in the town to rival Constantinople itself. As in many societies in demise, late Byzantium was a cauldron of intellectual and artistic ferment, and in no city was this more pronounced than in Mystra. As their world fell apart around them, the Byzantines produced works of art and thought that survived and germinated the Renaissance, even as the end was nigh. Constantinople was "the City," Salonika the perpetual "Second City,"[9] but both cities were old and scarred by the depredations of the Crusaders. The Constantinople restored to Byzantium in 1261 abounded in ruins, barren and occasionally cultivated fields. These cities ached with fatigue, almost palpable even today, when walking on their oft trodden cobblestones and lanes. Mystra at the time possessed vibrancy and vigor, and the intellectual and spiritual yearnings of a flowering youth. Here, as the Byzantines found

[8] Nikos Kazantzakis, Journey to the Morea, (New York: Simon and Schuster, 1965) 35.

[9] "Second City" is a deliberate borrowing from the description of Chicago, which considers itself the second city to New York City in the US.

themselves between the scissor blades of Western Catholics and Eastern Muslims, human creativity flourished. In the lands of post-Byzantium, it has never flourished in a comparable degree since that time.

Walking the ruined palaces and edifices today, scarred by time, war, and the misuse of ages of habitation without conscience, Mystra still displays its taste for subtle proportions, in the checkered brickwork of its palaces and delicately domed churches, its substantial fortifications, and its incomparable physical setting. In a rare burst of sentimentality, the author Robert Kaplan in <u>Mediterranean Winter</u> puts it perfectly, "for millenia architects have sought to recreate the beauty of nature. Here [in Mystra] brickworkers and stoneworkers had almost outdone her."[10] With a little bit of imagination and one can see the caftan-clad philosophers plying one another with theories under the shade of an omnipresent mulberry, or the grave purple cape of the mounted Byzantine despot riding by in a porphyry wave mixed with dust. Sometimes, the apparitions are very real.

As a young Greek-American yearning for a deeper understanding of our Byzantine identity, I dragged my father and mother to discover Mystra. As if yesterday, I remember the statue with a white marble backdrop, of a stately bearded man brandishing a slightly curved sword, in full imperial regalia. Constantinos Dragases XI Paleologos, the last emperor of Byzantium, the last Roman Emperor. Before he took the martyr's crown of Byzantium, Constantine served as a beloved, if somewhat impetuous, Despot of the Morea, encouraging its civic and intellectual life while seeking against all odds and hope to expand the realm of Byzantium north of the Morea, into lands controlled by Western or Turkish feudal lords under the general vassalage of the encroaching Ottoman Empire. For a time, he held most of what would become Greece south of Mount Olympus under his sway. But the Turks destroyed his ephemeral realm.

I fell to my knees at the sight of his bronze image, as my father, with tears in his eyes, recited his reply to Sultan Mehmet II, when he refused to surrender Constantinople. The words, in Byzantine Greek, summarize quite simply, 'it is not my right to bestow you with such a prize, only God can decide such a momentous transfer." A replica of the statue stands in Athens, close to the Metropolitan Church of Athens. When we lived in Greece, I would often take my own son to the Athenian statue, and, before

[10] Robert D. Kaplan, <u>Mediterranean Winter</u>, (New York: Random House, 2004) 214.

we left Greece, I took him to the original in Mystra, reminding the then three year old that this bronze enigma, like him, had a Serbian mother.

Recalling my first, youthful trip, we climbed further up the hill, my exact memories of events clouded in excitement, early adolescence, and a span of perhaps a quarter century dim, but I remember entering a the Church of St. Demetrios, where there is marble slab engraved with the Double Headed Eagle, the holy symbol of Byzantium and its successors, Hellenic, Slav, and even Albanian. On this slab, so our guide told us, a kneeling Constantine accepted the crown of Byzantium, in all likelihood knowing his fate. Exhibiting an emotion and reverence out of character, I fell on the slab crying, and the guard followed suit, unused to this emotion and astonished at it coming from an American-born person. The Church's frescoes, vivid still after over five hundred years, stood as witnesses to the actual event so long ago.

After leaving the church, where for a moment we were transported back to that fateful day in 1449, we emerged into the ruined lanes of Mystra, back to the small crowds of shorts-clad tourists clicking cameras and clucking in a series of languages. Apparitions did not end, as one part of Mystra continued functioning as in those times lost in a mist.

The convent of Pantanassa, with its delicate, intricate domes and tilework, beckoned the tourist overcome with thirst and emotion. My ten-year old eyes widened when a beautiful nun, clad in black robes straight from Byzantium, emerged with glasses and a timeless amphoric jar of water. I gulped down the vision and the water, and she waited with a patient, indulgent smile to fill my glass again, her doe-like eyes flashing a busy smile. The first yearnings of adolescence! I have always searched for that composite smile and the liquid eyes, and I found it over twenty years later, outside a Serbian Orthodox Monastery in the suburbs of Chicago, built in late Byzantine style, a copy of the Holy Monastery of Grachanitsa in Kosovo. The visage belonged to my future wife. It was therefore important that she saw the site of my first love, so that I could find my greatest love.

Later that evening, as we climbed down the Myzithra hill, we settled in a taverna situated near a hill, with a stream bisecting the scattered tables. The ice-cold rush functioned as the taverna's refrigeration, and waiters pulled cokes, retsina, and beers straight from the torrent. The stream was the source of the granite-filtered water that filled our waiting glasses. The sense of energy, spiritual and mineral, and the ghosts of the fierce and free mountain dwellers of Tayegetos, flowed over us like a cool, captivating embrace.

Mystra, like the Byzantine metropolis of Salonika, functions as a fulcrum of culture and chronology. In Mystra's case, the artistic and intellectual ferment coincided with the chronological. Just as the final sands emptied from Byzantium's millennium-old hourglass, the frescoes and philosophers of Mystra pre-figured the Renaissance, with fresh styles and ideas indicating a globalized and cross-fertilized culture. In the frescoes, severity of feature softened with humanist touches, soon to be snuffed out by the circumstances of Turkish rule. The iconography captures a calm before the engulfment, much as the artists of Serbia and Bulgaria in Monasteries of Kosovo, Boyana, and Rila captured the Indian Summer before the Turkish Ice Age.

Another fulcrum functions at Mystra, the balance between the Romaic (Byzantine) and Hellenic identity of modern Greece. Sir Patrick Leigh Fermor, details this dichotomy beautifully in <u>Roumeli: Travels in Northern Greece</u>.[11] George Gemistos Plethon, a Mystra philosopher in those last great days before the darkness, sought to revive the study and honor of ancient Greece in conjunction with the Byzantine Greeks' Christian identity. Western scholars, newly interested in Classical Greece, traveled to Mystra to visit with him, and so revered was he that a Venetian soldier who briefly wrested Mystra from the Turks in 1465 exhumed his remains to re-inter them in Italy. What Fermor emphasizes as dichotomy Plethon sought to integrate as a harmony. The Modern Greek state, claiming both the Classical and Byzantine legacy, is a highly dysfunctional attempt at putting Plethon into practice.

Mystra provides a glimpse of what might have been, had not the Turks smashed it all, and returned Byzantium to a calcified retreat. After the demise of these independent splinters of thought and culture, only small portions of the Orthodox world, notably Crete, the Ionian Islands, and Vojvodina, participated in the artistic, cultural, and intellectual development of the Western world to which the Byzantines used to belong, and in these cases at the sufferance of their Catholic rulers. The effects of this suffocation that occurred with the Fall of Byzantium can still be seen throughout the Balkans, and bears direct relevance to the current financial crisis in Greece today.

[11] Patrick Leigh Fermor, <u>Roumeli: Travels in Northern Greece</u>, (London: John Murray, 1966) 107.

On numerous occasions, the possibility of dawn from the Turkish night presented itself. The Turks' further advance into Europe received a decisive rebuff at the walls of Vienna in 1683, and a multinational Christian force of Austrians, Germans, Poles, and Venetians took the initiative from the Turk, and began to drive him back. The vast Hungarian plain fell to the Christian forces in the next twenty years, and at the same time, Venice, aged but still potent, wrested the Peloponnesus from the Turks, aided actively by their Greek and Albanian *stradioti* (the Italianized Greek word for "soldier"). The Venetians even moved against the Greek mainland, capturing Athens, and via a mortar shell, blew the insides out of the Parthenon.

In the wake of the Venetian armies came the Catholic priests, with the goal of bringing the "schismatic" Greeks to Catholicism. Once again, it seems that the West had learnt nothing from the past few hundred years, and the Greeks quickly lost interest in the new regime and on balance preferred the Turks, who allowed the Orthodox Church to function without undue hindrance.[12] However, the Venetians provided many infrastructure improvements to the Peloponnesus, particularly education, and the local Greeks took advantage of being part of "Europe" again to emigrate to Venice and points West. The Venetians' administrative capital, *Napoli di Romania*, today's Nauplion, is a pleasant town with an Italianate sense of grace and proportion rare in Greek cities.

The Turks swept away the Venetians by 1715, and the Greeks viewed this with mixed feelings. Actually, a few locals even converted to Islam at the time, for which a century later their descendents would bitterly pay.[13]

[12] There may have been other, far more secular reasons for preferring the Turks. They governed less, taxed less, and were more susceptible to graft. You get what you pay for, though, because higher Venetian taxes paid for schools and an improving infrastructure, while the Turks provided . . . nothing.

[13] On the eve of the Greek War of Independence, the Morea, like all other Balkan provinces of the Ottoman Empire, had a substantial Muslim population, Turks and (more numerously) local Muslim converts of various generations and degrees of observance. The Muslims of the Morea did not last the war, as most were killed, converted, and some survivors escaped. Those who escaped, Moraites (Morean Muslims) usually of Greek or Albanian descent and Greek speaking, survived as a small community in the Antalya region of southern Turkey until their ultimate assimilation into the Turkish majority. In the course of research into my own family, I found that our former surname, Meimetis (Mehmetis) might have been due to either a Turkish, Albanian Muslim, or Greek Muslim ancestor. According to

Later in that century, during one of Russia's interminable wars with the Ottoman Empire, Count Orlov arrived in the Mani Peninsula, the warlike southern tip of the Peloponnesus, and urged revolt. The Greeks generally looked to Orthodox Russia as a savior, and to the Tsarina Catherine as a coreligionist who actively sought to return the Byzantines to their former glory. Certainly Catherine the Great admired the Greeks and considered herself the heir to the Byzantine Empire, but *realpolitik* as always trumped sentiment. Mother Russia was a fickle parent to her Balkan children. The Greeks' second front helped to distract the Turks, but the Russians did not appear in force to prevent the Greeks from being overwhelmed and massacred by the Turks' vicious Albanian irregulars.

Fifty years later, the Peloponnesians took the standard of revolution in 1821, with the fiery Maniots in the south taking the lead, but the spiritual sanction occurring further north, in the Monastery of Agia Laura, on March 25. With the Archbishop of Patras blessing the standard, the whole "isle" rose, and every Turk or Muslim who could not escape to the fortresses was put under the knife. Having cleared the peninsula of Turks, the Greeks fell out amongst themselves, with open warfare at times. Here the various regions, clans, and interests all fell on each other, until the Turks with their French-trained Egyptian allies put the whole isle to fire and sword. Only at this point did the British, French, and Russians intervene. A semblance of independence arrived in 1829, after eight years of warfare, often as not amongst the Greeks themselves.

When Greece wrested its independence from the Turks, the Peloponnesus formed the bulk of the Greek state and Peloponnesians the bulk of the Greek population. The initial capital was Nauplion, which had been the Venetians' administrative headquarters and had the best infrastructure. In the side streets of this pretty town, near a small church, the first governor of Greece, Ioannis Kapodistrias, met his end from the bullet fired by a Maniot chieftain angry at the governor's attempts to centralize and modernize the tiny state. This Veneto-Greek nobleman from Corfu, who had served with distinction as Foreign Minister to Russian Tsar Alexander, gave his life in an ultimately failed attempt to create a modern state out of an Ottoman pashalik. The transformation awaits completion to this day. At times,

a distant cousin of mine, his and my ancestors, living in the high mountain villages of the Vatika, re-converted to the Orthodox faith of their ancestors and neighbors during the Greek War of Independence to save themselves and their properties. Who knows?

any Diaspora Greek who returns to Greece must share the frustration of Kapodistrias, though, hopefully, not his fate.

The capital moved to Athens in 1934, again to bolster the Classical credentials of this Byzantine successor state, but Peloponnesians and their conservative, Royalist sympathies helped to shape the Greece that emerged. Clans from Mani, Tripoli, Patras, and elsewhere took the reins of power and shared this unwillingly. The other Byzantine peoples joined to the Greek state would find themselves conforming to the state founded by Peloponnesians with a sprinkling of islander and Diaspora representation. Salonikans and those expelled from lands controlled by Turkey or Bulgaria would find themselves chafing, not always so mildly, under a state somehow more provincial than their more cosmopolitan visions.

The self-image projected by Greeks abroad, particularly in the United States (but far less so in Canada, Australia, Germany, and Britain), has been dictated by Peloponnesians. At least fifty percent, if not more, of Greek-Americans hail from the Peloponnesus. In some major metropolitan areas, such as Chicago, where we lived for many years, Peloponnesians are by far the dominant group, and they shape the perception of "Greekness" to their fellow citizens.

The hardy, enterprising Peloponnesians helped to create the Greek state by hard fighting on the ground and with a grand vision of an ancient past so admired by the West, including the counties, like America, that received so many of her immigrant children. Ironically, the legacy of Mystra is less understood and appreciated by Peloponnesians itself than its greatness merits. Here was the last gasp of Byzantium's greatness, which had been Europe's greatest civilization for a millennium. As the youthful Mystra fell into the coma of Turkish domination, its brief tenure as the place for art and culture inspired the cities of Italy to carry forward the Renaissance. Today Mystra lacks the preserved grandeur of those Renaissance capitals, such as Florence and Pisa, yet its intimate, crumbling arches are eloquent testimony to a lost civilization that gave so much. This Mystra, located in the heart of the modern state of Hellas, provided the spiritual, intellectual, linguistic, and cultural bridge from ancient to modern Greece.

Chapter IV

Athens, The Dense City

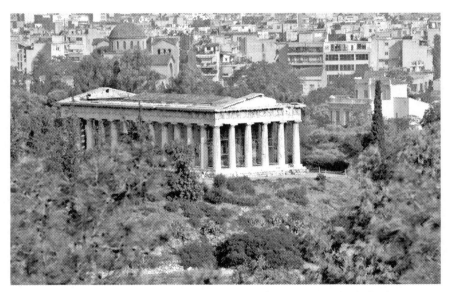

The denseness of old and new is readily palpable in Athens, both in architecture and in life. Photo by Keith Levit via Shutterstock.

Density and profundity, the terms best fitting for the Balkans in general, find a particular acme in this at once old and new city. One of the oldest cities in Europe, with monuments lasting the test of time and towering over the city, cast ancestral, and perhaps castigating, shadows on the concrete blocks below—the warrens of merchants, brigands, peasants, and refugees from the recent century. Sublime beauty and crass ugliness jockey for position, much as the vehicles, cafés, and pedestrians in the crowded streets with irregular or no sidewalks. Few cities possess such glory *in situ*, and struggle to come to terms with it in life and architecture.

Athens, assuming a legacy of Ancient Greece and Byzantium in duo, struggles to combine these with the modern world that is moving at an exponential speed. How difficult the task—one started from the day the Greek state, a struggling *pashalik*[14] emerging from Turkish rule, chose its capital here, in the shadow of Classical glory. As if this were not enough, the Greeks also grafted to the Classical Greek legacy that of a giant empire, the Byzantine, onto the narrow shoulders of their wobbly state. Via the Megali Idea (literally, the "Great Idea"), the small kingdom sought to regain the lands of the Byzantine Empire, a task far beyond her capabilities.

The enormity of that task burdened the poverty-stricken Greek state until, in the 1920s, the glorious task of imperial resurrection became a disaster of Olympian proportions, with defeat deep inside the vastness of Turkey. Athens is not a metaphor, but *the* metaphor for the all of the traumas of Hellenism reborn, and it seems that its every success and failure has settled into Athens' parched hills and valleys. Today's financial crisis, where Athens is at the center of the global sovereign debt meltdown, is no exception, but rather the rule.

Walk the streets of Athens, emerging from the subterranean, marbled coolness of the Athenian Metro to Syntagma (Constitution) Square, a plaza fronted with the rather forgettable Parliament Building and landmarks of luxury and intrigue such as the Grande Bretange Hotel, towards the Acropolis. Here is where the manifold demonstrations as common to Greece as beautiful weather usually have their epicenter. Just off the

[14] Pashalik or Pashaluk, is the Turkish term used in many Balkan languages to denote the territory belonging to a pasha's jurisdiction. In Serbian, the term is a pejorative diminutive used to describe a country or state that is dysfunctional, corrupt, and capricious. Serbs will often refer to Serbia as *Beogradski Pasaluk* (Belgrade Pashalik) when annoyed at their country or its corruption.

square, following narrow streets with concrete monsters gently straddling centuries-old churches, one comes to the Metropolitan Church of Athens.

All Balkan capitals have a central church, one that stakes its claim to the Byzantine past. When compared to Belgrade's St. Sava Cathedral, in its "Saint Sophian" splendor, Sofia's Aleksandur Nevski, a multi-domed monument to Slav Orthodoxy, or even Skopje's St. Kliment Ohridski Church, the Western-influenced Metropolitan Cathedral of Athens disappoints. The relatively nondescript church belies the Byzantine yearnings of the Greek people, a situation adequately addressed by the Cathedral's understated, subtle surroundings. The Metropolis Square contains an exquisitely proportioned yet tiny brick Church from the mid-Byzantine period, and a statue of Archbishop Damaskinos, Greece's heroic World War Two era prelate.

Smaller in proportion, shaded by plane trees, there is another statue, of another hero, Constantine XI Paleologos, the last Byzantine Emperor, brandishing his scimitar, his Serbo-Greek visage a mask of pride and tragedy. This statue, a replica of the one in Mystra, provides the finest symbol of continuity between past and present. In a small, eminently subtle way, it stakes Athens' claims to the mantle of the "unattainable" Constantinople, the dream of all Balkan Orthodox. Another martyred hero rests in the Metropolitan Church, the Ecumenical Patriarch Gregorios, hanged by the Turks in retribution for the Greek rebellion in 1821. Dumped in the Bosporus, a Greek captain retrieved his vestimented corpse, and brought him to Odessa. Later, the Russians bestowed his bones to Athens. Time and again, when we lived in Athens, I sought solace in the shade of this small square.

When Athens became the capital of Greece in 1834, it was but a small village of winding streets flanking the glories of the Acropolis. Many of the inhabitants, like others in the province of Attica, spoke an Albanian dialect, *Arvanitika*, ironic given the Classical Greek aspirations of the new state. In an attempt to Europeanize the Ottoman village that became the capital, Greece's first king, Otto of Bavaria, commissioned Western European city planners to design his new capital, which was to fan out in large squares and boulevards, growing into a pleasant, neo-classicized Balkan city. From there, Athens expanded organically and almost elegantly[15] in the first fifty

[15] Certainly the few remaining neoclassical homes and structures from this early post independence era are often quite lovely. Their successor structures nearly always lack the taste and the workmanship of the past, something also in evidence in other Balkan countries.

years of its post-Ottoman existence. Its port, Pireaus, also a resurrected ancient city, absorbed nautically inclined islanders, including my father's Hydriot relatives.

With the arrival of the twentieth century, Greece and her Balkan neighbors, fueled by dreams beyond their means, threw down the hammer on the Ottoman Empire, nearly ejecting the Turk from Europe. Then the Greeks, in the purest form of imperial folly, took the war against the Turk to Asia, and met disaster in the middle of Turkey. The Greeks of Asia Minor, resident for three thousand years in some cases, were expelled, many finding their way to Athenian shanties.

The Greek state, lacking means to provide real welfare to her new citizens, used a primitive form of squatters' rights to compensate. Where the refugees landed, they built, throwing city planning out the door. The districts they founded bear the names of lost Asian homelands; their taverns a more Eastern flavor to their food. Their roads were narrow, with no sidewalks (a still-chronic problem in Athens). Following the Second World War, and the dislocations of the Greek Civil War, in some sense a continuation of the legacy of the demographic and economic upheaval of the Asia Minor catastrophe[16], brought even more refugees to the city.

Land being virtually the only resource, the venerable neoclassical buildings of an older Athens and one-story refugee dwellings were pulled down to make room for a newer, more vertical, almost exclusively concrete Athens, not much different than the concrete monstrosities in the cities of Greece's communist neighbors. For example, Sofia had similar dislocations from large influxes of refugees after the Balkan Wars, and Sofia[17] has this similar disorganized layout, though the sheer scale of sprawl does not compare to Athens (yet), and the Communist Bulgarian government did have planning ordinances that were to some extent followed. Further,

[16] Catastrophe (Καταστροφη) is a Greek word. Whenever the term, "the catastrophe" is spoken in Greek, automatically every Greek knows that this refers to the Asia Minor Catastrophe; it is burned in our collective consciousness.

[17] When I lived in Sofia in 1994, the concrete sprawl was still confined to the damage from the Communist era. Since then the construction boom and the over-concentration of economic and political activity in Sofia has resulted in a considerable increase of congestion and concrete. It seems that Sofia would like to "out-Athens Athens." Belgrade is also doing its level best in this dubious sweepstakes, and Bucharest may be the worst of all.

Communist governments did not respect property rights, so in spite of the ugly concrete "Socialist Realism" architecture of ex-Communist cities (shared with Athens), the cities in ex-Communist Europe often have large boulevards and sidewalks. Property generally constituted the only capital of the majority of Greeks through most of the Twentieth Century, and the state respected the individual's property rights in spite of the architectural and planning chaos that logically ensued.

Patrick Leigh Fermor commented in Roumeli that every time he went to 1960s Athens, even after an absence of a few months, he would lose his way as old landmarks met the wrecking ball and new ones sprouted rebar, waiting for the next floor to be stacked onto the previous one. A hotel or memorable café, a former site of discourse, libations, and intrigue, would be gone with each visit.[18] Athens here sets the stage for its fellow Balkan capitals, as Belgrade changes each time I visit, even in the space of a few months, with more concrete, car-occupied sidewalks, and a mounting urban chaos.

The disappearance and dislocation architecturally alluded to by Fermor only continued at a faster pace between 1969 through 1974 under Greece's criminally idiotic dictatorship, where freedom from construction regulations, I suppose, substituted for human and political freedoms. By the 1980s, the city had become a heat island of simmering concrete, with Third World infrastructure and a leaden smog. Having withstood all comers, the Parthenon's White Marble began to react with the myriad toxins in the air to transform its delicate surfaces into a powdery limestone.

The pace of architectural insult began to slow in the 1990s, as the Athenians became aware of the damage they had wrought on themselves, but not enough for Olympic candidate Athens to win a bid for hosting the 1996 Olympics—the Centennial of the Modern Olympics. The International Olympic Committee cited infrastructure issues as a key factor for awarding the 1996 Olympic Games to Atlanta.

As the millennium drew to a close, Athens won, after a hard fight in 1997, the right to host the 2004 Olympics. Work to make the games a success and to reap some needed infrastructural dividends began, with the assistance and frustration of the European Union. In some cases, the venues were finished only *hours* before the start of the games! The world however acknowledged the great success of the very Greek Athens Olympics, finished just in time and indicative of the Greeks' faith in

[18] Fermor, Roumeli, 116.

last-minute completions—and just plain luck. Athens shone with its new infrastructure, services sorely needed for daily life. After years of "creative" redirection of structural funds, Greece and her capital began to use the EU structural funds for infrastructural and cultural preservation needs, again just in time before the funds began to dry up, and to be redirected to the new Eastern European members joining the EU.[19]

In spite of the definite improvements in the capital's infrastructure, there is a quality of the "Potemkin Village" in these shining improvements. The metro is stunning, but covers too little of the city to have a decisive impact on the gridlock. Parking in order to access the metro is negligible. Spanking new off-ramps clog into winding oriental lanes; tram and metro lines stop in illogical places; and high speed internet flows fitfully and unpredictably over an antiquated and still state-run telephone network. Speaking of the Olympic venues, moreover, these are already showing signs of decay and wear due to lack of proper maintenance, in spite of their recent construction. This just points to Athens'—and Greece's—thin civic culture. The same can be said of Greece's sovereign debt meltdown.

In the language of the new world economy, "network" conjures up images of straight-through processing, integration, flow management, efficiency, and timeliness. Athens possesses facades of such infrastructure and knowledge, like Potemkin's Village, but there is little integration of the various parts of the infrastructure to provide a workable "network." The "non-networked" nature of Athens makes it a tough city to live in, to work in, or to invest in. In an era of globalization, where homogenization creates efficiency, Athens stands defiantly in the breach, though this defiance may be less a function of deliberate obstruction and more an act of a culture deeply imbued with an Ottoman mentality. Density, of architecture, history, and mentality make Athens a most fascinating and selectively delightful place, but like a heavy meal, certain morsels are hard to digest. Further, when the bill comes, Athens must pay on credit.

[19] Of course, now that Greece is in the throes of a financial meltdown, the huge expenditures for the Olympics are viewed, probably correctly, as a contributing factor to the crisis.

Chapter V

Salonika: The Perpetual Second City

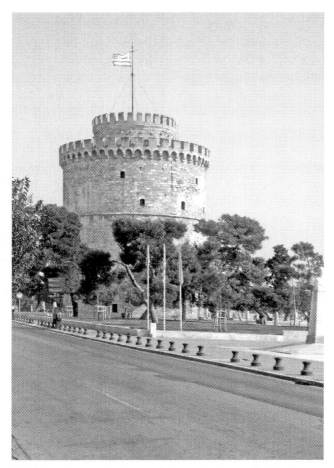

The White Tower, a Venetian addition to the Byzantine harbor walls, and the signature symbol of Salonika. Photo by John Billinis.

While Athens draws its inspiration from ancient glories, Salonika represents the continuity of Hellenism expressed through Byzantium. No city within the confines of modern Greece matches Salonika's pithy Byzantine credentials, its proximity to Mount Athos, its position as Byzantium's second city, and its status as the birthplace of the Apostles of the Slavs, Cyril and Methodius. The city has "that something"—*to kati* as we say in Greek, which enthralls visitors and instills in its natives a breathless devotion. In Chile I met a Salonikan-born Jew who became misty-eyed recalling his natal city, its crescent-shaped harbor, and its crowning citadel.

I have visited Salonika several times on Greek sojourns, and each time the city captivates me and presents its considerable contrast to Athens and its monochrome statist reality. Salonika is the cauldron of Byzantium, mixing together its Hellenic and Slav elements to create a pastry appreciably different from that of Athens.

Salonika more fully mirrors the reality of the Balkans and post-Byzantium than its southern capital, which rallies around a particular period of Classical glory. As a port city with open horizons, in some ways Salonika accurately reflects the Hellenism of pre-1900, with Greek communities stretching from Marseilles to Tblisi—cosmopolitan, commercial, and intellectual. If any city in the Balkans represents the region's center of gravity, it is Salonika.

One million Greeks inhabit the city and its environs, and the city's once thriving Jewish community was near totally destroyed by the Nazis in World War Two. The Orthodox Slavs and Vlachs of the city have generally assimilated into the Hellenic Orthodox mass, though Salonika has small, distinctive Serb, Bulgarian, and Russian expatriate communities, bolstered by thousands of recent immigrants. The city's Turkish community returned to Turkey with the 1920s population exchange, brokered by the Salonika-born "Father of Modern Turkey," Kemal Attaturk. Their place was taken by hundreds of thousands of Greeks from Asia Minor, Pontus, Bulgaria, and Russia; a process that continued after the collapse of the Soviet Union, as ethnic Greeks from Russia, Ukraine, and Central Asia left for Greece. Though Athens is also a primary destination, somehow the more Balkan, Byzantine and Anatolian Salonika seems more familiar to these wide-horizoned "New Greeks."

The first time my wife visited Salonika, she remarked on its similarity to Belgrade. These things are so subtle, but there is much truth to the familiarity between the two cities. Greece's northern metropolis, with its northerly winds from the Vardar River, clearly does possess some kinship with Belgrade. Belgrade I describe as a city both at the center and on the periphery. Much the same can be said for Salonika. The Aegean port constitutes the fulcrum of the Balkans, the center of gravity for the cultural world of ex-Byzantium, an hour's flight from Athens, Belgrade, Bucharest, Istanbul or Sofia. Salonika's deliberately named Macedonia International Airport flight scheduler tells an interesting story. Destinations such as Bucharest, Belgrade, Skopje, Odessa, Tblisi, Kiev, Moscow and other "Byzantine Commonwealth" venues outnumber West European destinations. The Headquarters for the Black Sea Trade and Development Bank also boasts a Salonika address, as does the Center for Diaspora Hellenism, the Institute for Balkan Studies, and other centers of Balkan cooperation.

And yet, Salonika somehow seems on the periphery, and suffers from a mild complex as the perpetual second city. Eclipsed by Athens in the modern era and Constantinople in the Byzantine Era, Salonika lies outside the fast lane of its particular civilization. Indeed, its proximity to Slav Orthodoxy often fosters tongue-and-cheek taunts from Athenians, who refer to Salonikans as "Bulgarians." To be sure, there exists a Slav element in Greek Macedonia but Athenian purists (a ridiculous notion anywhere in the Balkans, or anywhere on earth for that matter) might also remember that their own hometown and its environs were populated in part by Albanian-speakers. The site of Athens' new ultramodern international airport is a dry plain east of the city where the local villagers often still chat in *Arvanitika*.

Salonika's proximity to the Slav world, moreover, fostered and perhaps created the basis for Byzantium's crowning achievement—the conversion of the Slavs to Orthodoxy. Geography is destiny, and Salonika's position as a Byzantine island in what was, during the early eighth century, a Slav-inhabited sea, clearly positioned Salonika to play a vital role in the Slavs' Christianization and absorption into the Byzantine cultural realm.

Alex Billinis

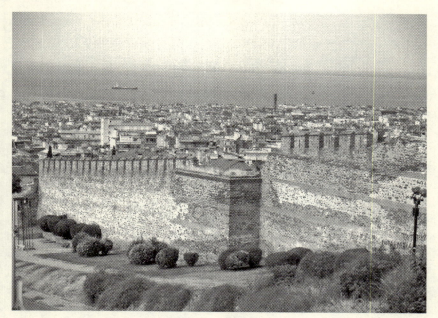

Salonika Fortress, guardian of Byzantium's Second City. Photo by Alexander Billinis.

On every trip to Salonika, I take a cab up to the old city and the fortresses. I climbed upon the walls of the fortress, not far from modest but smart, gentrifying homes, and I thought of what these walls have witnessed—sieges, conquests, successful resistance—but always the walls were permeable, like a cell membrane, defending against diseases, sometimes succumbing, and sometimes expanding outside their circumstances. Cities always played this role of mediator and processor, and in Salonika's case the urban Hellenic Christian culture successfully fended off pagan Slavs, and then undertook a soft, osmotic conquest of the Slavs' souls.

Two Salonika boys, Cyril and Methodius, brought the word of God to the Slavs in their own language, with their own alphabet, and carried the institutional and cultural infrastructure of Byzantium wherever they went. As I sat on the walls, as certainly, the brothers had done over one thousand years before, I could not help thinking that this proximity and intimacy with the Slavs outside—and probably inside—the walls lent itself to a great understanding between Slavs and Byzantines. I have always suspected that Hellene and Slav are culturally complementary. But this closeness and understanding of both peoples for one another—characteristics no

doubt shared by the brothers—contributed to the wholehearted and utter assimilation of Byzantine Orthodoxy by the South Slavs, and later the Russians. The religious and cultural accoutrements of Orthodoxy fit Slavs and Greeks like a glove, though each hand retains its separate—though mirror—identity.

They say that familiarity breeds contempt, but it also brings both understanding and humanity. There is no doubt that Byzantine citizens such as Cyril and Methodius, whether or not—as Bulgarians and Slav Macedonians claim—they had Slavic blood, might have looked down on the Slavic hordes they set out to convert. Their condescension, however, was of a milder version than that of Western Europeans who converted north Slavs and Balts—often by the sword. Further, Byzantines would never assume that Greek alone was fit for the Liturgy and Gospel, and they provided the liturgy and the means for the Slavs to express themselves in their own language. The Slavs fully assimilated the religion, liturgy, and the trappings of state, on their own terms, voluntarily, and speaking their own language.

The Greek Army liberated Salonika from the Turks on St. Demetrios Day, 1912, taking the city about 18 hours ahead of their erstwhile Bulgarian allies. Salonika thus suffered longer the weight of Ottoman rule than southern Greece, much of which was independent since the 1830s, and in its aura one feels greater coloring of Turkish culture than in Athens, a situation exaggerated by the presence of so many descendents of Asia Minor Greeks. In other ways, however, the city feels more Western, or at least Central European, than Athens. Salonika's broad avenues and cafes have a hint of Vienna, like a crème *shlag* on your coffee. Salonika had been a major outlet of Central European goods to the Mediterranean, and like its northerly "sister," Belgrade, Salonika was not immune to the cultural trends from the Hapsburg realm.

Perhaps, though, Salonika's more European, Western feel comes from its Byzantine civic pride and continuity. Salonika from its founding in the Classical Era has been a major European commercial, administrative, and cultural center. When Athens was a minor town, Salonika was the second city of the Byzantine Empire, and during the Ottoman Era, Salonika continued to be a major city with a diverse population and economy. Athens, Sofia, and Belgrade were far smaller towns until the end of the nineteenth century, and none had the civic grandeur of Salonika. What I may be revealing is my own biased preconception that civic and orderly

is somehow "Western." Salonika's civic depth, its Byzantine legacy, combined with elegant influences from Vienna and elsewhere, together with its former ethnic diversity, in my opinion, make the northern capital a far richer experience than Athens.

Macedonia and Thrace Map. Byzantium's Heartland.

Chapter VI

Macedonia: A Region, and a Reality

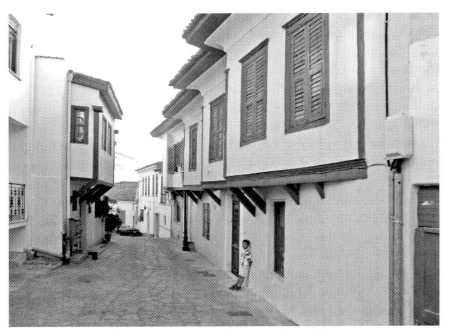

Kavala Old Town, near the fortress. Such hilltop towns, crowned by fortresses, dense with Ottoman urban architecture are typical of Macedonia. Photo by Alexander Billinis.

Few words or places are as loaded with meaning as Macedonia. Always connoting a mixture searching for a more defined reality, Macedonia defies attempts at compartmentalization. Broader, inclusive definitions begin to do it justice, but attempts from any quarter to narrow fail in the face of empirical evidence.

Macedonia and its inhabitants, the Macedonians, do possess a broader common culture and inheritance. Macedonia was an Ancient Kingdom of Classical Greece, peripheral to its centers of power and culture, but nonetheless a constituent part. This hardy kingdom knocked out the Persian Empire, nemesis of the Greeks, and brought Greek culture to the far reaches of Central Asia and the Indus Valley. This is a heady legacy for a modern nation to claim, and it is no wonder that certain modern nations claim Alexander the Great's mantle. Who would not want such a legacy?

Macedonia passed over to Roman rule after the Battle of Pydna, which occurred in 168 B.C. on the slopes of Mount Olympus, and over the course of centuries Macedonia fully absorbed the Roman identity, which itself incorporated and assimilated Greek culture. Saint Paul first set foot in Europe at the Macedonian port of Neapolis, known today as Kavala. He preached at nearby Philippi, the one of the cities Philip II, Alexander the Great's father, named after himself. Philip's son would outdo his toponymic exploits, with dozens of Alexandrias to his credit. Salonika, the crescent shaped port town, then as always the fulcrum of Macedonia, on the Roman Via Egnatia, also received the Word of Christ from the Apostle Paul himself.

Roman Macedonia accepted Christianity, and its population, Greek and Latin-speaking, successfully resisted the Gothic onslaught. In the fifth century, however, the Slavs came *en masse*, and their ethno-linguistic bloc absorbed Latins, Greeks, Thracians, and Bulgars. The Greek-speaking element shut itself in the fortresses, and, as always, along the coasts, where Byzantine naval technology bested the land-loving and riparian Slavs. The Salonikan monks Cyril and Methodius created the literary and liturgical means for absorbing the Slavs culturally and spiritually, but also provided the infrastructure for separate Slav states. North of Salonika, in central Macedonia, Slav languages prevailed regardless of the political control, which shifted from Byzantium, to various Crusader states, Bulgaria, and the Serbian Kingdom of Tsar Dushan, until the Turks swept all before them.

Turks brought all Orthodox Christians, regardless of their language, under the rule of the Orthodox patriarch. They were all *Rums*, the Turkish word

for Roman, for Byzantine. Thus, until the twentieth century, when asking an Orthodox Macedonian his nationality, the response was nearly always, "Rum."[20] And why not? After all, the ethnolinguistic soup of Macedonia was long a mixture of Greek and Slav, together with Latin-speaking Vlachs, and typically the population was bilingual, or multilingual, and illiterate. The Greek state, pushing its borders to the southern reaches of Macedonia, assumed that the Macedonian Orthodox would all flock to her banners as a successor of Byzantium. The error in the assumption was that Bulgaria also was a successor to the same culture and fought for the souls and the tongues of the Macedonian Orthodox as well.

The Bulgarians were quite successful in bringing the local Orthodox population of what is now the Former Yugoslav Republic of Macedonia ("FYROM" or "Slav Macedonia")[21] to the Bulgarian identity. As the Bulgarian Orthodox Church separated from the Patriarchate of Constantinople and started serving liturgy in Slavonic rather than Greek, they received a great number of adherents, particularly in the regions north of Bitola and Ohrid. Like the Greeks, the Bulgarians poured money into local schools, teaching the language and national identity of the sponsor state among the local Orthodox, prior to the wars for liberation of Macedonia. That the Turks allowed these subversive schools to operate under their rule is a testimony as much to their tolerance as to their indifference, and ultimately, their incompetence in ruling. The Bulgarians' plan to incorporate the much of Macedonia into Bulgaria would likely have been successful had not the strategy of the Balkan Wars intervened.

The Balkan States realized that only concerted military effort could expel the Turks from the lands they still controlled in Europe, and to achieve this, they buried their differences to form a loose alliance called the Balkan League. Geography to a great extent dictated strategy. Greece and Serbia would strike north and south respectively to mop up Epirus, Albania, and most of Macedonia. Bulgaria would strike south and east, towards eastern Macedonia

[20] Rum (Turkish), Romios (Greek). The translation literally is "Roman," meaning an Orthodox inhabitant of the Ottoman Empire, and a former subject of the East Roman Empire or Byzantine Empire.

[21] When referring to the Former Yugoslav Republic of Macedonia, I will use "FYROM" or "Slav Macedonia" in this book. This reflects my opinion that the Slav Macedonians are a component part of Macedonia, but not the whole. I do acknowledge that they are Macedonians, just as Greek Macedonians, or any inhabitant of Macedonia, is a Macedonian.

and Thrace. The allies were quite successful in driving out the Turk from nearly all of the Balkans, to the gates of Constantinople, but the Bulgarians were effectively locked out of much of Macedonia. In order to get more of Macedonia the Bulgarians attacked Greece and Serbia, and were defeated, and Greece extended its sway in eastern Macedonia. Bulgaria was left with only a small chunk of geographical Macedonia on its southwestern border.

Many Macedonians who identified with Bulgaria then left for Bulgaria or actively sought a redrawing of borders. Districts of Sofia filled with Macedonian refugees or exchangees, similar in plight if not in vast scope as the refugee situation that would develop further south in Greece after the Greek-Turkish population exchange in the 1920s.

Bulgaria sided with Germany in both World Wars, in ultimately failed attempts to wrest Greek and Serbian held parts of Macedonia, and in some part it was a response to this, and to the failure of Serbian national identity to take hold in Yugoslav Macedonia that a local identity, the Slav Macedonian, emerged. Tito's Communist movement gave this identity full support and it received a fair amount of support from the local Macedonian population.

After the war, Tito used the infrastructure of a Communist dictatorship to instill a separate Macedonian identity. Emulating the Turkish sultans and Byzantine emperors whose authority he effectively inherited, he decreed the establishment of a "Macedonian Orthodox Church" separate from the Serbian Church, just as the Sultan did for the Bulgarian Orthodox Church, a century before. This decree in the 1960s by an atheist Communist leader seems ridiculous, but in fact it reflected a keen understanding of Orthodox history. Orthodoxy has always believed in national churches preaching the language of the people, and only a nation has the right to a separate church status. With a separate church, the Slav Macedonians become a separate people, a nation with the right to a state of their own. To date, no other Orthodox hierarchy has recognized this separate church. Further, in Orthodox nations, the Church is subject to the State, whether that of Emperor, Tsar, Islamic Sultan, or Marxist Dictator. Tito proved a shrewd student of history.

This Slav Macedonian identity, calling itself simply "Macedonian" without modifier to region or to ethnicity, dug deep enough roots in the eponymous Yugoslav republic to become the true representative identity of its Slav Orthodox majority.[22] Equally, and in fact perhaps more importantly,

[22] In retrospect, it astonishes the degree to which most Greeks, and Greek-Americans, were unaware of a "Macedonian Issue" at all before the

the large Diaspora of Slav Macedonians who quit the country for Australia, Canada, Germany, and to a lesser extent America often actively embraced an extreme nationalism directed against Greeks and Bulgarians. This was complicated by extended families with different national identities, and the fact that Greeks, Serbs, Bulgarians, and Slav Macedonians are all Orthodox Christian and thoroughly inter-mingled. Further, Greece suffered a vicious Communist insurrection after World War Two, and Slav Macedonians in Greece generally supported the Communists who promised to award sections of Greek Macedonia to the Yugoslav Macedonian Republic. The Greek forces then pushed out thousands of Macedonian Communists of Greek or Slav background in retaliation. Many of these people left for the West after a period in Yugoslavia.

In places like Toronto, Melbourne, Chicago, or Dusseldorf, the result could be pitched battles at football games, or fistfights at churches and family gatherings. This peaked in the first few years after the Slav Macedonian Republic declared independence in the early 1990s, but in recent years has receded, particularly as Greece invests heavily in its neighbor and "on the ground" relations generally are quite familiar and cordial. Indeed, there are times when the Diaspora (on both sides) seems to have home country politics by the throat, to the detriment and resentment of the locals. Often as not, Diaspora nationalism is more extreme than that of the locals.

The current Macedonian Issue centers on the name, or what modification or composite of it, will be the final name of Slav Macedonia. Both Greece and Slav Macedonia probably wish the whole issue would go away, but the rest of the political game seems to be played on two levels. The first is public rhetoric, where each side compromises a little, but not enough to reach an agreement, and thus satisfies key domestic lobbies. For the Greek side, it is a sop to hardline nationalists, including the National Popular Orthodox Front, which takes the ironic tough stand against a fellow Orthodox state. For the Slav Macedonian side, the same extreme lobby is sated, along with

1990s. I had seen a Yugoslav Republic called "Macedonia" on the maps, but I just assumed it was a geographical expression, much like Greek Macedonia. Greeks in Australia and Canada were more aware of the issue but the first time I heard about it was in a drunken political discussion I had, over twenty years ago, with a British political consultant on a train from Budapest to Prague. He told me in no uncertain terms that the Slav Macedonians were going to get independence from Yugoslavia, and that they had territorial designs on Greece.

their Diaspora benefactors, and, ironically, the Albanian minority which stands to gain from the further destabilization of the Slav Macedonian state. As Greece's economy enters what can only be called a Depression, it will be interesting to see what role the Nationalist Card will play in politics, both for the Macedonian Issue and other sensitive national issues.

The second level is subtler. Greek and Slav Macedonian cooperate on the business front, in tourism, and in slowly uniting families who bridge the ethnic divide. Proximity breeds both contempt and understanding, and the two peoples are really one, united by culture, religion, and often enough by blood and language.[23] Many people on both sides of the border speak both languages fluently and would be obvious benefactors of more open borders and broader cooperation. Further, Greece fully supported the Slav Macedonian government in the face of Albanian separatists, and can be counted on to assist the Slav Orthodox in any future conflicts, even if the Nationalist lobby objects.

To the outside world, it seems that the only Macedonian Issue is that with Greece over the name and historical associations of Macedonia, but there is also a severe, and perhaps existential threat from Albanian separatists, emboldened by the amputation of Kosovo from Serbia. Another, less obvious existential threat comes from Bulgaria, as Bulgarians have recognized the "State" of Macedonia, but not the nation. Bulgarians believe the Slav Macedonians are Bulgarians with a slightly different dialect, separated by war and politics from the Bulgarian nation, and the Bulgarians offer passports to Slav Macedonians. Either out of sentiment or in the interest of obtaining the passport of a EU state, there are many takers.

Greek Macedonia

Macedonia is diverse, even within its component parts. Greek Macedonia, much the largest slice, has a diverse population and landscape, in spite of its titular ethnic uniformity and its Mediterranean climate.

[23] In interviews with descendents of Communist Greek refugees in the mainly Greek populated village of Beloiannisz, Hungary, I often found them to be bilingual (in Greek and Slav Macedonian) and proud of their Greek identity. They did resent Greek government interference in their broader vision of Hellenism, but beyond that, there was little evidence of conflict between the two groups. This is in direct contrast with other Diaspora locations, particularly Canada and Australia.

The province clearly shows the demographic effects of ethnic engineering. The large Muslim population, whether Turkish, Greek, Albanian, Slavic, or Sephardic Jewish in origin, departed for Turkey as a result of the Greek-Turkish population exchange. Several hundred thousand Greeks from Turkey, Russia, and Bulgaria took their place.

The almost surgical effect of the population exchange is self-evident when entering Greek Macedonia from Thrace, by crossing the Nestos River. On the Macedonian side of the river, there are no Muslims at all, as a result of the exchange, whereas Greece's province of Thrace still possesses a large autochthonous Muslim population. Following the path of the Ancient Roman Via Egnatia, Greece's Northern Autobahn, Egnatia Odos, slices Germanically through the fertile fields of Eastern Macedonia, passing villages built in near-military grids to house the incoming refugees from nearly a century ago. Arriving in Kavala, a pretty amphitheatre of a town with crenellated fortresses and the best-preserved aqueduct in Greece welcomes the visitor. Macedonia's second port, it received thousands of Asia Minor refugees, and many, like my brother-in-law's family, planted roots there. Some appropriated housing from outgoing Turks or Bulgarians; other received prefabricated homes.

The Roman Via Egnatia, from Durres on the Adriatic to Istanbul, via Bitola, Salonika, and Kavala. This Roman Road was Byzantium's superhighway and the inspiration for the modern Egnatia Odos, at times flanking the Roman one, which runs across Greece's Epirus, Macedonia, and Thrace provinces. Photo by Alexander Billinis.

It is an architectural scene repeated in dozens of Greek cities, particularly those in the north. Land was allocated, and utterly utilitarian homes lined roads that were no more than muddy lanes, narrowly built in an era when nobody believed the automobile would one day become ubiquitous. As in other such districts, the street names recalled lost homelands in the East, and by the 1980s nearly all of the squat homes had been replaced by multistory flats, with large balconies, well-appointed interiors, and an abundance of concrete, in typical Greek fashion. In some cases, the older parts of the city retained their old-style homes and charm, but in a Greece where funds were scarce and this scrap of land often the refugees' only capital, they maximized the living space at the expense of aesthetics, often with the help of a family member in Germany or Australia sending Deutschmarks or dollars home.

Heading westwards on Egnatia Odos, one passes through tobacco country and villages generally well-kept and prosperous. Most of the population is of refugee background. Their Hellenism is quite pronounced and often has more of a religious edge than in southern Greece. Attachment to their Macedonian homes, and to their Macedonian identity is as much a result of the sting of expulsion as it is for the pride in the local identity. Asia Minor Greeks rightly consider that their sacrifice fully secured Macedonia as Greek in the face of a considerable Turkish and Bulgarian/Slav population. Non-refugee Greeks in this part of Macedonia have generally coalesced into the general Asia Minor Greek milieu, which contrasts with Macedonia further to the west.

All along the Bulgarian border rises a high mountain wall, the Rhodope chain, providing a natural frontier behind which a refugee-fortified Greek state coalesced against the Bulgarian military and demographic threats. Now the mountain chain is a barrier to open trade between two latter-day friends, both EU members. The border actually is a historical anomaly, as the norm for over two thousand years was a single economic and cultural unity, and rather than building the fortifications still in evidence along the border, today's efforts are focused on upgrading road and rail links between two important trading partners.

Interestingly, the Sarakatsan herdsmen, a Greek-speaking subculture, always alternated between the highlands of Bulgaria and the Aegean coasts, following their flocks and not the dictates of state and ideological politics. As soon as the Communist government fell, they returned to

their past seasonal migration, with the blessings of both the Greek and the Bulgarian governments, who immediately relaxed visa restrictions for this community. Today, of course, there are no visa restrictions between Greece and Bulgaria, as EU members.

To the west of Salonika, Egnatia Odos brings us quickly into the realm of western, mountain Macedonia, where the Mediterranean climate fades into the semi-alpine. Here the refugee impact is less in evidence, and the local Macedonians of multiple linguistic backgrounds predominate. Pride in Macedonia as Greek is profound, but conversations reveal more. To find out, one must ask questions tentatively. A few years ago, in the Munich airport, bound for Salonika, I remember talking to an elderly couple from the Greek Macedonian town of Naoussa. I asked them if they were "local Macedonians" or of refugee background. They replied "local." I asked them if they knew "Slavic," and they nodded with sheepish smiles, and I continued in Bulgarian, using the Slavic name for their hometown, *Voden*. Chuckling, they switched to Greek, and the man made a very valid point, "son, we live in Germany, we were born in Greece, we grew up in Greece, we went to school in Greece. I served in the Greek army. Greece is my country." They further related that their son was married to a German, "so we are all mixed. That is Europe." In Kozani, a pleasant hilly town, our hotel proprietor commented on the intertwined background of Orthodox Macedonians, but in the context that "we are all one people, one religion."

Further north, on a pretty lake lies the city of Kastoria, *Kostur* to Bulgarians and Slav Macedonians. The city is world-famous for its furriers, and Russian buyers were ubiquitous. In Bulgaria I chanced on a dozen people with roots in the area, and walking the hilly streets of this eminently Byzantine town, one easily feels as if they could be in Ohrid on the other side of the intra-Macedonian border, or in any number of Bulgarian towns I visited when working there. Simply change the language and the flag. The underlying architecture and religious adherence are the same.

Further, language itself matters less historically than one might imagine, as plenty of Kastoria's citizens can speak Bulgarian or Slav Macedonian, and their ancestors could as well. Further north, on the other side of the intra-Macedonian border, Greek was often heard in the past, and is still spoken in the present. If this issue was of paramount importance to people, they immigrated to these lands where "their" language was spoken, if not, they stayed *in situ*. To say they assimilated is not quite correct, because

they already belonged to an age-old Byzantine culture. Only the language and successor state was at issue.

Memories in Sepia

My family and I had the great pleasure to know a 90-year-old Serbian-American gentleman and his family when we lived in Milwaukee, a lovely, winter-battered Midwestern city on the shore of Lake Michigan. He was born in 1913, a year before the outbreak of World War One, and a year after the conquest of Macedonia by the Balkan States in 1912, in a multicultural town called *Monastir*. Monastir, or *Bitola* as it is also called, is one of those quintessential Macedonian cities at the twilight of the old Ottoman regime. Serbian armies thundering down from the Upper Vardar Valley delivered a knockout blow to the Turks on the town's outskirts, and then linked up with their Greek allies a few kilometers south, where the present border lies.

The Bitola of the late *Barba (Uncle) Ratko* was a place where the mosaic of cultures still existed, Greeks, Serbs, Bulgarians, Turks, Vlachs, and Jews lived, to a degree, in harmony before the assimilations and expulsions began. In the course of half a century, the majority of the Turks left, the Nazis murdered most of the Jews, and the various Orthodox peoples coalesced, over time, into Slav Macedonians.

The first cinematographers of the Balkans, the Manakis brothers, Milton and Yiannis, in whose studios the youthful Ratko took his first portrait, were born *Rum* citizens of the Ottoman Empire, speaking the Vlach dialect and Greek, then lived as Serbian citizens in Bitola, and Milton, who remained in Bitola and passed away there, is today remembered as "a pioneer of Macedonian cinematography." Cities such as Bitola were cauldrons of such diversity, but the states that took over such cities, though they possessed a common Byzantine culture, passed a narrower version of the common identity onto the citizens.

The Slav Macedonian identity, itself a version of the East Roman, is to a great extent the continuation of this localization and, most appropriately, the "Balkanization," of the common culture. As a result, Milton Manakis in his lifetime transformed from a *Rum* speaking Vlach and Greek, to a Serbian, to a Slav Macedonian (and of course, a Yugoslav). His brother Yiannis ended life as a Greek citizen of Salonika. The brothers are a human

metaphor both for the essential unity of Byzantium and for the succession process to nation-states.[24]

On the [Macedonian-Macedonian] border...

A modern road punctuated by occasional lapses in upgrading (oh, eternal Greece!) reaches the international (and inter-Macedonian) border in less than an hour from the Aegean coast. Even in winter, the Greek side of the border is still jacket and pullover weather, but the border hails the arrival of the mountains that shield Greece from the chilly interior weather of the inner Balkans. Border guards on both sides speak both languages, and a huge casino on the "Slav side" of the border is filled with Greek gamblers. Along the border, other areas of commercial and industrial cooperation proliferate. Your mobile phone receives an SMS message, which warmly "welcomes you to Macedonia," and the operator is Greek-owned. Many of the billboards advertise Greek companies, and well over fifty percent of the foreign investment in the country comes from south of the border. Businesspeople from both sides of the frontier generally work well together, and lobby the government to keep rhetoric to an unobtrusive level.

In spite of so much commonality within Macedonia and among Macedonians, the differences are indeed stark. The north south highway in Slav Macedonia is a four-lane highway, built during the old Yugoslavia to traverse the country from the Greek to the Austrian border, but in looking at the highway, the Serbian saying *sto juznije to tuznije* (what is further south is more bitter), expresses itself infrastructurally here. The road utterly lacks the crispness and precision of roads in the West, or the new Brussels-financed Greek autobahns. It is *a la Balkana* here, and tunnels remain *au naturel*, just holes blown through the rock and resembling grottoes ill lit. Then the weather strikes, much harder than a few kilometers behind these mountains, to the south, in Greek Macedonia. The palm and the olive tree seem to provide the internal demarcation of Macedonia, and the Greek zone is contiguous with that which is Mediterranean, and the Bulgarian, Slav Macedonian, and Serb zones with the wintry, continental part. This is far more a divider than language and economy, both of which are so malleable.

Well to the west of this north-south highway, near the Albanian and Greek borders, Ohrid on the lake of the same name is a statelier,

24 Please see the film "Ulysses' Gaze", directed by Theodore Angelopoulos with Harvey Keitel in the starring role. Keitel portrays a Greek-American filmmaker investigating the legacy of the Manakis brothers.

more cerebral version of worker-bee Kastoria further south, playing an Oxford to Kastoria's Edinburgh. Ohrid is the original intellectual center of Slav Orthodoxy, and it is from here that much of the foundations of Slavonic liturgy and literature were established. Ohrid and Kastoria both have patterned brick Byzantine Churches, hill town architecture, and the cobbled lanes with Turkish-style wooden second floors, often in a state of dilapidation but in other cases latest renovation rage. Both cities spring from this common Byzantine culture, expressed through an Ottoman prism, and the Greek, Bulgarian, Serbian, or the Slav Macedonian flag could fly over these towns without much change to the underlying identity. The border is, after all, nothing more than where the Greek and Serbian armies met and lowered their rifles, as allies in the Balkan Wars.

Continuing northward on the old Yugoslav highway, the road improved and deteriorated at various steps, but the late December traffic was light, and the weather cooperated. Towns, vineyards, and isolated Orthodox churches faded into the fog, and slowly other religious architecture appeared, as we neared Skopje and headed slightly westward. This too, had been a common sight in Greek Macedonia of the past, though mosques in Greece generally became theatres, museums, or, as we saw in Kastoria, dilapidated monuments with a latter-day attempt at restoration. Rarely did they keep their minarets, except in the functioning mosques of Thrace and Rhodes, and a few in Epirus, on Crete, and in Greek Macedonia, stuck "like a spear in the ground"[25] by a lost warrior. Here, near Skopje, we found the "unexchanged Macedonia" where a large Muslim minority exists and which is rapidly increasing in population. Most Turks from Yugoslavia left for Turkey, but the Albanian Muslims remained and demographically stood poised to return parts of Macedonia to the Ottoman age, but without the diversity and greater subtlety that existed under the Turks.

As we passed near Skopje, or rather its airport, a sight I never saw before spoke most poignantly of the state's infrastructural challenge. The airport's navigation lights to the runway ran through a suburbanized village, through backyards, on rooftops, wherever, in the most haphazard way. Though I would love to revisit Slav Macedonia more often and do more justice to it, I reminded myself not to route my trip through

[25] An expression borrowed from Sir Patrick Leigh Fermor. See Patrick Leigh Fermor, <u>Between the Woods and the Water</u>, (London: John Murray, 2004) 230.

Skopje Airport. The Serbian border was not far away, and the autobahn, now much improved, cleaved through or bypassed more minaret-spiked villages, all the way to the Serbian frontier, at Presevo, in December a heavily snowed valley demographically weighted to Albanians overflowing from Kosovo or Slav Macedonia.

What strikes home, when driving through the Balkans, either on new roads or Balkan tracks, is the lack of cities in the civic sense. Most of the towns either had a Roman or Byzantine foundation, or were simply jumbles of homes and rude shops centered around a Church or a Mosque. Nothing spoke of plan or organization, and that which existed was either very old, or very new and generally not very well done. This was equally true in Greece, Bulgaria, Slav Macedonia, and through most of Serbia and Romania. Only when one reached Vojvodina, Serbia's northern province, did a real civic sense return. No town halls, theatres, elegant schools, unless they were Byzantine remnants or the legacy of a rich benefactor who made good in commerce or politics. Many of the schools in Plovdiv, Bitola, Ioannina, and elsewhere owe their establishment to such individuals, who succeeded in the West or somewhere abroad, and remembered their homeland. The state, as a rule, could care less and after independence strong regional centers of commerce and culture often declined in favor of Athens, Sofia, or Belgrade. This trend is continuing, and in fact accelerating; the capitals drink the lifeblood of all of the Balkan countries.

Leaving the region of Macedonia, the only reality is that the region that gave its name to a French mixed fruit salad[26] continues to be diverse, just as in the past. The diversity makes it impossible for any one part or group in the region to speak for the whole. The irony is that the Orthodox nations and peoples who live there may call themselves different nations, but they are part of the same Byzantine family. Brethren they are, but this fact alone has never precluded quarrels. Perhaps the opening of borders and the opportunities of commerce and the presence of real existential threats will make the Macedonians celebrate together their common dances, music, and festivals, regardless of the language of the music.

[26] *La Salade Macedoine* is a French mixed fruit salad. The idea is that within the salad, the diverse elements retain their own character, just as the diverse peoples of Macedonia are said to maintain their diverse character in spite of their regional affiliation.

Chapter VII

Bulgaria, the Deep Balkans

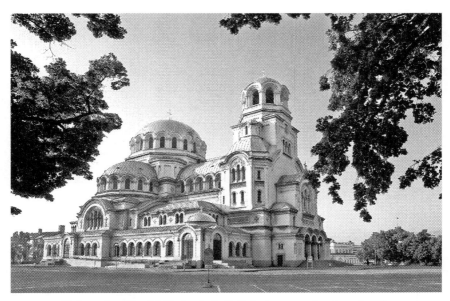

Aleksandur Nevski Cathedral, Sofia's signature landmark. The Cathedral is just over a century old, built by the Bulgarian people to honor the 200,000 Russians who died to liberate Bulgaria from the Turks. Photo by Ilya D. Gridnev via Shutterstock.

Alex Billinis

Bulgaria always fascinated me, so close to Greece, yet for the first twenty years of my life, so far, locked behind the Iron Curtain. So much history, culture, religion, and blood crosses the border between the two countries, and that has been a source of the love-hate relationship between the two nations and peoples. One Bulgarian friend summed it up for me—"between you and us, there is no border, that's a big part of the problem." When, after finishing business school in Spring of 1994, I had the opportunity to work for the summer in Bulgaria, I jumped at the opportunity.

"There is no border . . ." Indeed, sometimes, clear definitions of where one identity ends and the other begins is conducive to peace. For example, Greece and Serbia have generally been allies, and the affinity is strengthened by a common religion and culture. The same, even deeper, ties between Greece and Bulgaria have not precluded mortal enmity between the two peoples. The difference, of course, is geography, a lack of those "borders." Hellenic and Serbian identities do not overlap; Danubian-centered Serbia and Aegean-centered Greece both dissolve somewhere in the Balkans, but the Greek and Bulgarian (and Serbian and Bulgarian) identities have no frontier, which creates conflict in spite or, and perhaps because of, their common identity. Ironically now, as EU partners, as of late 2010 the border is a mere passport wave, and when Bulgaria joins the Schengen Treaty, there will be no border at all between the Greece and Bulgaria.

To travel in Bulgaria is to witness first hand the strength and continuity of Byzantium, expressed through its Slavonic prism.

The architecture, culture, and people are clearly East Roman; with a deep imprint of the Ottoman legacy, itself a distended and unintended successor of Byzantium. The East headily permeates Bulgaria, and contact with the West via the Danube and Austria-Hungary, such as Serbia or Romania had, or via the Aegean, such as with Greece, was limited, again, by the effects of geography. The East, by contrast, whether East Roman, Tatar, Russian, or Turkish Islamic, had ready avenues into Bulgaria. This makes Bulgaria the least "Western" of all of the major Balkan states.

Mountains, rivers, and a virtual inland sea hem in this cauldron of cultures, creating a feeling claustrophobia within its beautiful green valleys. Climate smiles kindly upon the country, a mixture of Mediterranean and Continental, with a periodic dose of the steppe, reminding the locals whence their Bulgar ancestors (and their Turkish oppressors and Russian liberators) came. No wonder, then, that the country is an archeological tell of thousands of years of civilization.

In traveling through Bulgaria, one never feels far from Greece. The same combination of Classical and Byzantine, with the patina of Ottoman, dots the landscape. Hellenism, through its various manifestations, occupied a huge space. It is the same in Turkey. Turkey is a veritable necropolis of Hellenism, a journey of loss and mourning. In Bulgaria the feeling differs in that the current custodians of the land are Orthodox Christians who cherish the monuments of Byzantine Christianity as their own, though they may emphasize the Slavic Orthodox element in their dual (and dueling) Byzantine identity. Thus, while the Churches may celebrate liturgy in Bulgarian rather than Greek, the religion is the same, the church is functioning, and the parishioners are carriers of the same cultural and religious identity. The only differences are the somewhat temporal and fungible ones of language and state identity.

The First Slav Empire

Notwithstanding this inextricable tie to Hellenism, Bulgarians possess a great pride in their history and identity, and quite rightly. Theirs was the first literate Slav civilization, the first to be Christianized, and the first to be recognized by Constantinople as a separate, national Orthodox Church. The Bulgarians paved the path for other Slav states, such as Serbia and Russia, in carving out their own secular-sacred identities as Orthodox empires modeled on Byzantium through the Bulgarian Slavic prism. While Western Europe was in semi-savagery, the Bulgarian capitals of *Pliska* and *Veliko Turnovo* were mini-Constantinoples with high culture and literacy, and Bulgarian power was recognized far and wide. Bulgaria's power, prestige, and persistence created the model for Slav states that followed, and for the Romanians, who received the Word of God from Bulgarian missionaries, and the Romanians' first alphabet was the Cyrillic, borrowed from the Bulgarians. Thus, when we consider the spread of Orthodoxy and of Byzantine civilization, the Bulgarians played a central role, one not remotely adequately recognized by historiography.

While Bulgaria did become an Orthodox stalwart, it was not without haggling. Bulgaria's clout induced the Pope to attempt to win over the Bulgarians from Orthodoxy to Catholicism, but the centripetal pull of Constantinople and its civilization was too great to provide for a long-distance dislodgement from Constantinople. Indeed, the pull and universality of Byzantium was such that the Bulgarian Kings proclaimed

themselves Tsars (Emperors) and, like other Orthodox Slavs, referred to Constantinople as "Tsarigrad"—the city of Emperor. There could be no other. With that in mind, they made several attempts to capture Constantinople, all ultimately unsuccessful. Nonetheless, Bulgaria's rule at times extended over much of Romania, Serbia, Slav Macedonia, Albania, and parts of Greece.

While all of the Balkan Orthodox states recognized their common culture and the sacred universality of Byzantium, their secular leaders could not resist fighting amongst themselves for the title, to the point where their common enemies from the West and the East subdued them. The Turks combined overwhelming force with a willingness to leave Orthodoxy at peace and subdued all of the Balkans. The Turks shattered the Bulgarian forces at the Battle of Maritsa in 1371, and Bulgaria would not rise again until 1878, five hundred years later.

The hammer of Turkish rule fell with varying degrees of force on her Balkan subjects, but generally Bulgaria suffered the strongest blows due to her proximity to Constantinople. Turks settled here in depth, and their communities, together with those of Slav Bulgarian converts to Islam, remain to this day. Over ten percent of the population is Muslim, and the word for Bulgarian convert to Islam is *Pomak*, a corruption of the Bulgarian word for "collaborator." *Pomak* villages cluster in the Rhodope Mountains on both sides of the Greek-Bulgarian border.

At Street Level in Sofia . . .

Bulgaria is the deep Balkans. All Balkan peoples with the partial exception of the Bulgarians accept but somewhat chafe at the notion of being "Balkan." Bulgarians wear it with a mixture of pride and possess a real understanding of its complexities and complexes. The positive and negative connotations of the term find their fullest expression in the country and its inhabitants.

Outside of the effects of fifty years of communism one still finds beneath the surface a highly traditional peasant society reeling from the effects of stultifying Turkish rule, and a clear sense of mourning for lost greatness. Communism has exacerbated this sense of grievance. The country is very poor yet extremely well educated, with world-class intellectual and technological expectations unable to be fulfilled inside Bulgaria, which sends their best and brightest, and even more importantly,

their most civic-minded, abroad. This is a common Balkan predicament, and it seems that every generation prepares and educates a new flow of emigrants.

Not only do Bulgaria and Greece share the past, but in many aspects they share the present as well. Sofia brought the wrecking ball into the city and replaced the few venerable neighborhoods with ugly, poorer versions of Athenian concrete architecture. In 1994 some businesses made attempts to smooth the rough edges of concrete storefronts with Plexiglas and wood facades that have become ubiquitous in post communist Europe and parts of Greece. These stores, if anything, by attempting "too much," only emphasize the thinness of civic and commercial culture.

Not only were the stores ugly and overpriced, in the 1990s they were dangerous places to own or to frequent as mafia "tax collectors" brazenly arrived for their cut. I remember sitting one very pleasant afternoon in a Sofia cafe nursing a *Zagorka* Gold, a fine Bulgarian beer, and a delicious *meze* of feta and peppers. A Mercedes stopped flat in front of the shop, a squat well-muscled man with a briefcase stepped out, flanked by tall, thick heavies. They walked inside, and through the tinted window, I saw the goons down complimentary *rakiya* while loading currency stacks in the briefcase. They walked out after a few minutes, threateningly stared down any onlookers, and sped off.

The iron fist of the state had been amputated, but the recently urbanized Bulgarians had little civic legacy to fall back on. Turkish rule rested on a troika of neglect, corruption, and capricious violence, and these traditions were very conducive to the formation of mafias and neglected infrastructure that only now, with European Union (EU) membership, are the Bulgarians confronting. While some of the mafia violence has receded recently, the culture of graft has been bolstered, if anything, by the infusion of EU funds. As a result of Bulgaria's corruption, the EU has used the temporary withholding of EU funds in an attempt to induce changes.

A true diamond in the roughness of Sofia exists, appropriately, in a religious monument, the Cathedral of *Aleksandur Nevski*. The towering Neo-Byzantine Cathedral, sheathed in bronze domes and bell towers, is truly a monument of the Bulgarian people and by the Bulgarian people, but in honor of the 200,000 Russians who gave their lives in the Russo-Turkish War of 1876-78 to secure Bulgaria's emergence from the Turkish slavery. A subscription paid for the beautiful edifice to Orthodoxy and to Slav

brotherhood. Until I saw Belgrade's majestic St. Sava Cathedral, so "St. Sophian" in its grandeur, I thought that this sacred temple in the heart of an otherwise overgrown concrete village called Sofia was the fullest expression of Orthodoxy—vast, orbital, at times as dark as outer space, at other times shining with celestial brilliance—that I had encountered.

Architecturally Aleksandur Nevski Cathedral was a link between the Orthodoxy of Mediterranean Greece and the Orthodoxy of Slavdom, both in the Balkans and in the vastness of Russia, all the way to former Russian Alaska. The cathedral's crypt often hosted religious art exhibitions, where (in 1994) exquisite icons could be bought for a song. I purchased a few, one of which, depicting St. George, I gave to my uncle of the same name.

While the beautiful cathedral presents an obvious riposte to Sofia's concrete jungle, what went on inside these often battered "socialist realism" living quarters often deeply impressed me as well. To be sure, plenty of urbanized peasants occupied these quarters but often as not a Sofia home would be spotless, even as the streets outside, the hallways, or the apartment elevators might resemble a latrine. Shoes were off and slippers provided immediately by your host or hostess. Bookshelves heavily weighed down with tomes, often in two or more languages. One seldom saw so much literature in an American home, or the attention to detail given to their limited space. Good wine, spirits, flowed, together with excellent *meze*. The conversation would span the languages and the topics, and the participants clearly knew their subjects.

This was the positive side of Communism, the deep investment in education. My Bulgarian colleagues at business school in America received scholarships to study abroad, paid for by the otherwise debt-ridden, poor, and corrupt Bulgarian state. Before we judge systems in absolute terms, we may want to consider the positive elements. Education in Communist societies stands out as a qualified, but definite, positive. It is the one aspect of the otherwise rotten old regime that I sincerely hope survives.

Sofia does not figure high on most travelers' itineraries, nor does the prospect of an assignment there impress many would-be expatriates. I consider myself fortunate in having spent several months there, under circumstances dangerous yet civilized, exotic while achingly familiar due to my Greek background. Sofia dominates the country, in the post-Communist era far more than previously, when settlement in the capital required permission. Like Athens, Bucharest, and Tirana, and to

some extent Belgrade, Sofia like a giant straw drinks the lifeblood of the country, to the detriment of other cities with far more architecturally and culturally, than the capital. Cities such as Plovdiv.

Second Cities . . . Plovdiv

Plovdiv plays Salonika to Sofia's Athens, a "Second City" far more cosmopolitan and architecturally agreeable than its capital. Though increasingly eclipsed by statist, concrete Sofia, Plovdv is a true Byzantine metropolis with well over two millennia of civic history and pride. With its several hills recalling Rome or Constantinople, Plovdiv through most of its history was known as Philippoupolis, named after Philip II of Macedonia, who captured the site from the Thracians. His son, Alexander would well outdo his father's conquests and toponymic exploits, but Philippoupolis became a lasting center of commerce and culture.

That Plovdiv rather than Sofia became the capital of Bulgaria is an accident of history, perhaps unfortunate for the inhabitants of Plovdiv but nonetheless preserves the city's charm, as it might otherwise have given way to concrete, the wrecking ball, and other dubious forms of "progress." After Russia liberated the bulk of Bulgaria, Macedonia, and Thrace from the Turks in 1878, they tried to create a "Greater Bulgaria" incorporating today's Bulgaria and much of the latter provinces. The other Great Powers—and Greece and Serbia—were appalled, each for their own reasons. The Great Powers quickly restored Macedonia and Thrace to Ottoman rule, and divided a much smaller Bulgaria into two provinces, Bulgaria, which included most of today's northern and western Bulgaria, with its capital at Sofia, then a large village, and Eastern Rumelia, which included much of southern Bulgaria, including the cosmopolitan city of Philippoupolis. The Bulgarians quickly united the two provinces, though Sofia retained the position as the country's capital, no doubt to Plovdiv's chagrin.

Plovdiv possessed, and still possesses, the civic pride and spunk typical of old, diverse, Byzantine metropolises, and the Turkish period, in some ways, added to the city's diversity. Turks and other Muslims rubbed sholders with Orthodox of Bulgarian and Greek speech, Armenians, and Jews. Greek and Turkish were as common as Bulgarian in street discourse, and the Sephardic Jews preferred either Medieval Spanish (Ladino) or French. While the Turks did not invest particularly in education, wealthy Greeks, Bulgarians, and Jews endowed the city with schools and institutes. Often

these benefactors were from the Diaspora, particularly, in the Greeks' case, Vienna and Russia. The schools' talented graduates often followed the example of the schools' benefactors, and themselves left for the Diaspora. Here is the irony. Usually the most talented leave, the very ones that might effect a civic transformation in the Balkans. This is still the case.

Black Sea Bulgaria

In a country as cozily claustrophobic as Bulgaria, the Black Sea coastline provides the country's one open horizon, the country's lungs, in effect. Here the Bulgarians have a distinctly Mediterranean dash, much like Greek islanders, Here too is a much more mercantile and seafaring Bulgaria, traits less in evidence further inland. I have always found coastal people have a certain sophistication and gait, a breezy air that inland people disdain and perhaps, secretly envy. Here one finds a string of towns and cities with a long Byzantine and mercantile history, with long standing connections throughout the Black Sea basin and beyond. The coast of Bulgaria spoke as much Greek as Bulgarian until well into the twentieth century, and in the cafés and beaches of Varna and Sozopol, I often met locals talking about their "Greek" grandparents, and they themselves often as not addressed me in quite passable Greek. The coastal Bulgarians are proud of their country's history, but they are natural cosmopolitans who prefer open horizons and prospered most when borders—and minds—are open. The rigid state environment of the Cold War and hermetically sealed nation-state identities is certainly not for them. What shipping was in the past, tourism has become in the present. When I first visited in 1994, the beaches still catered primarily to East Bloc and Russian tourists. Now all Europe, east and west, enjoys the sun and sometimes the dense cultural inheritance of three millennia of high civilization.

I cannot think of Bulgaria without feeling a slight lump in my throat. They were the first nation to take the Greco-Roman Christian culture of Byzantium and graft it onto the their Slav state, so in a sense the Bulgarians are the co-founders, along with the Byzantines, of Slav Christianity. This hardy, dour yet lively nation produced one of history's ephemeral Great Powers, plowed under by half a millennium of the harshest of Turkish rule, with little light coming in from the enlightenment-powered West. The few portals of light during the dark Ottoman night, such as Plovdiv and a few of the Black Sea towns, shine in utter contrast to the general

emptiness of that period. This may be why the Bulgarians have a dourness and taciturnity that their Greek neighbors, with whom they otherwise have so much in common, utterly lack. The only way I could definitively tell a Greek from a Bulgarian is that the Greek would smile and laugh, and when the Bulgarian did, it really meant something. Something moved him deeply.

Chapter VIII

Thracian Impressions, the Edge of Greece

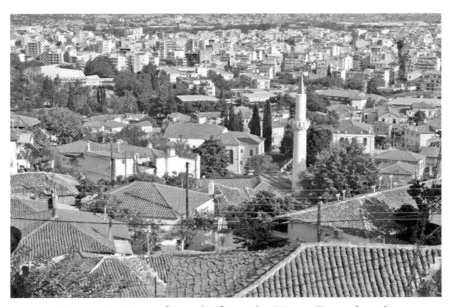

Panoramic View of Xanthi from the Upper Town, heavily Muslim with more traditional architecture, to the lower town, heavily Greek and Orthodox, where modern buildings predominate. Photo by Stratos Safioleas.

"Thrace? What about it," my relatives told me. "It's so far away, and so different."

This was in Kavala, a coastal town in Eastern Macedonia only a couple dozen kilometers away from the Nestos River, which separates Macedonia from Thrace. My Athenian relatives were more blunt: "What?! No one goes there! There is nothing to do, there are only Turks, and who really wants to see them?" Another response was from those who had been stationed in Thrace during military service, mourned in the lyrics of Greece's modern bard, Dalaras: "Dhidhimotiko Blues." This was where the Greek army kept most of its strength, massed against a much larger Turkish force. This is where, until the recent thaw in Greek-Turkish relations, it seemed likely that a confrontation would eventually occur.

Needless to say, Thrace is not exactly on the itinerary of most tourists. Others, however, more of the traveler frame of mind, did say that the province had incredible, unspoiled physical and natural beauty, in many ways preserving the "state of nature" in human and natural form better than the rest of Greece, which was developing at a fitfully, and not altogether balanced, pace. In particular, I was interested in the demographic and cultural dynamic of the province, the only place in Greece with locally rooted Muslim populations.[27] In 2002, in the aftermath of the Yugoslav dissolution, traveling with a Yugoslav girlfriend (now my wife), I approached my trip with a bit of trepidation and a great deal of anticipation.

The route to Thrace from Kavala is covered quickly, in a new superhighway financed by European Union Structural Funds from Brussels. As such, much of Greece is a construction site, building infrastructure that is sorely needed. In our case we were traveling on the Egnatia Odos (Egnatia Highway), a twenty-first century manifestation of the old Roman

[27] The only other region where a local Muslim population has remained in Greece is the Dodecanese Islands. A couple of villages on the island of Rhodes and one village on the island of Kos have Muslim majority populations. The Dodecanese Islands were Greece's last territorial gain, after World War Two. Italy had wrested the islands from the Ottoman Empire and their small Muslim population was not part of the Greek-Turkish population exchange. The relations between Christian and Muslim on the islands are very cordial, the Muslims generally are Greek in ethnic origin and speak Greek as their mother tongue, in contrast to the majority of Thracian Muslims, who are Turkish or Bulgarian-speaking Pomaks.

Via Egnatia, which roughly follows the same course across Macedonia and Thrace, arriving, eventually, at Istanbul.

As we approach the Nestos River, I proclaim theatrically, "we are crossing the ethnic frontier of Greece." As if in agreement, the first village on the other side of the river proclaims its identity skyward with a minaret. Not a church bell tower in sight. The next villages we cruise past have similar features, as if beacons navigating the traveler out of Greece and into the East. The superhighway bypasses these locations, as if they are cut off from the mainstream and the commerce of Greece. As we near Xanthi, our first destination, we flip around the radio, and "Turbo Folk" music blares away. "Turbo Folk" is another unifying theme of the Balkans; most of the ex-Byzantines, Greeks, Bulgarians, Turks, and Serbs, have shockingly similar tastes in somewhat vacant, vapid music. The lyrics were Turkish, not surprising, as Turkey is close by, but the station identification was Xanthi, one of Thrace's principal towns. A radio station in a foreign language is not unusual in Greece—Greeks are voracious students of foreign languages, but the languages in question are typically major foreign languages, not languages of neighboring states in conflict with Greece. This was a very different place.

Downshifting, we pulled off toward Xanthi. Like most autobahn exits in Greece, the German-standard pull-offs descend to Greek-standard roads, and a rough Balkan two-laner brought us into the city.

Our first approaches into the city were winding streets, filled with market day shoppers. First the minarets, then the mixture of people, filled our eyes. Turkish women identified themselves with their veils and pantaloons, a clearly conservative community wherein outward signs of religiosity also served to proclaim their ethnic identity, and the best example of this was a Greek fellow speeding by a church on a downward curve, who nonetheless managed to cross himself three times in rapid succession. Mosques of great antiquity and delicate artistry shared the cityscape and skyline with Orthodox churches immaculately cared for in this interfaith city. Xanthi's streets probably would be familiar to a turn-of-the-last-century Balkan, when national border and exchanges and expulsions had not yet turned the countries into monochrome colors. Xanthi's kaleidoscope of ethnicity and gives us an outward picture of harmony between the two antagonistic cultures of Greek and Turk.

Xanthi seemed familiar to my wife, who had studied architecture in Sarajevo at the moment her Yugoslavia began to disintegrate. There too

one witnessed a mix of Orthodox and Muslim on the street, and in the architecture. Of course, in Sarajevo, they all spoke the same language, and many considered themselves Yugoslavs, an amalgative nation wherein common language and a common Slavic ethnicity were supposed to create a national identity. In Xanthi none of this existed; there was no pretense of common identity. Orthodox and Muslim went to separate schools, Orthodox meant Greek, and Muslim meant Turkish. Sacred space was separate; identity was separate, only the civic realm was shared space. Could what happened in Sarajevo happen here?

This question went through my mind as we sat down for a coffee, in a lovely wooded café not far from the Upper Town, next to a rocky stream. Exhibiting a hospitality consigned to Greece's "roads less traveled," the proprietor treated me to a tsipouro, and my wife to a fresh squeezed orange juice, along with our coffees. In the atmosphere of easy informality that I love in Greece, he took a chair and began: "Relations between us and the Muslims are good, why should they not be? We are neighbors." Continuing, he said, "My parents were thrown out of Asia Minor. Nobody should be thrown out of their homes, we must learn to live together." At a neighboring table, another café patron offered, "only events and people from outside cause trouble here, not us locals." My wife nodded, as she said similar things about the violence and the breakup of Yugoslavia; the pot seemed to have been stirred from the outside.

Walking up into the heavily Muslim Upper Town felt like passing to a previous century. It provided a glimpse as to what other Greek towns, such as nearby Kavala or the Castle District of Salonika, looked like before the Turks' expulsion. Local Turks were shy but friendly, and when we lost our way, an older man, speaking to a matron in veil and pantaloons, broke off his conversation and he insisted on taking us back to the center himself. He spoke fluent but accented, ungrammatical Greek, and when I thanked him in my few words of Turkish, he bowed ever so slightly and wished us a pleasant visit in "our beautiful town."

Xanthi is indeed a lovely town with plenty of traditional architecture, nestled against the foothills of the Rhodope Mountains and bisected by a lovely, rocky river. Not for the last time I witnessed the mellowing and harmonious effects of architecture and topography. The city is well kept, with winding cobbled streets, and a new sense of civic drive. Xanthi's relative isolation from the centers of Greek political and economic power had the positive effect of preserving old architecture, which in

more "favored" Greek cities would have been consigned to the wrecking ball. The result is that beautiful and rustic Balkan town architecture has remained, and the largesse of the Greek State, bankrolled by the European Union, has been channeled toward more restorative and preservationist projects.

From Xanthi one glimpses a cautiously optimistic view of the potential for Orthodox-Muslim relations, though perhaps this viewpoint is viewed from the parallax of the tourist or the historicist who reads perhaps too much into chance encounters with local Greeks and Turks. Sarajevo had all of that and more, and it descended into a maelstrom of war. A local painter told us that relations between Greeks and Turks were actually better than the relations between local Greeks and recent Greek arrivals from Russia. This was not the last time I heard about refugee versus local antagonism in the Balkans. In Serbia I hear it nearly every day. Local Sombor Serbs have little time for the numerous Serbian refugees from Croatia and Bosnia settled in their midst.

For another glimpse of the province, we continued east on the Egnatia Highway toward Thrace's other large town, Komotini. We promised that we would return to Xanthi via the old road, but for now we took the Autobahn option. The four-lane superhighway delivered us quickly to the Komotini turnoff, after passing dozens of blurred villages with their minaret signposts. Once again, we transitioned infrastructurally from Germany to the Balkans once we got off the autobahn, bouncing our way into Komotini.

While Xanthi is blessed by topography, Komotini is not. A late August visitor finds a garrison-bazaar town in the middle of a dusty plain. The city boasts a few Byzantine military ruins, some impressive mosques of great antiquity, and competingly grand (and newer) Orthodox churches. The city's central market looks, feels, and sounds as if one has left Europe and passed fully into the Middle East. Aside from a few boulevards with the preserved homes of late nineteenth century merchants, the majority of the city's architecture is a poorer, more "Turkish" version of eyesore Greek concrete residential architecture.

As we glided into one of the numerous row cafes on Komotini's central boulevard, watching veil-clad women walk by with numerous kids following, at a slight distance, their skull-capped men in shabby but clean suits without ties, I fell into conversation with a local Greek. He too assured me in almost defensive terms that relations with the Turks—the Muslims, as he "officially" called them—were harmonious, "why shouldn't

they be?" Certainly the local Turks showed us no animosity as we strolled through the bazaar, politely answering our inquiries in good Greek.

Perhaps what jaded our impression of Komotini beyond the shabbiness of the architecture was a monument in the city's central park. The monument, a war memorial, evoked monuments I had seen in ex-Communist countries, with a chipping marble background, and an huge, oxidizing copper sword in relief. "It's like a warning," my wife said, "both to Turks and to Greeks." I thought of the Bible passage about living by the sword and dying by the sword. Thrace, like the rest of Greece, was won by the sword, and the Thracian frontier with Turkey is one of the most militarized spots in the world. I felt the presence of the heavy mailed fist of the state in a way I had never felt before. I could imagine life here would be very difficult for the Turkish minority whenever relations between Greece and Turkey became particularly tense. On the other edge of the "sword," life for the Greeks living in the role of conqueror and defender of the conquests against a much larger Turkey hardly is an enviable position.

Our itinerary for this particular trip did not take us further east to the official border between Greece and Turkey, but instead we returned toward Macedonia via the "old road" for further local color. The road, built in the 1950s, primarily for the Greek military, skirted the railroad, which skirted the Rhodope Mountain range. Again, we sped through villages that time and progress forgot, much poorer than villages in other parts of Greece, and the majority of the populace, judging by the profusion of minarets and veils, was Turkish.

The greatest (and missed) photo opportunity of our trip was a scene in a small village. Picture a small, domed, and immaculately cared for Greek Orthodox Church with a groomed, fenced yard. In the foreground, there is a sidewalk bench, upon which two middle-aged veiled Muslim women sit in subdued conversation, waiting for the bus or, more likely, for a relative to fetch them. This is, in many ways, a metaphor for Thrace; the ownership is Greek, but the demographics are increasingly Turkish. Thrace's challenge—and opportunity—will be to find a solution to this paradox. This is made all the more complicated by the growing cultural and economic power of Turkey. The threat is no longer just, or primarily military, it is the centripetal power of Istanbul, a few hundred kilometers away, with its fifteen million people once again having a magnetic force on the rest of the region.

Arriving at the outskirts of Xanthi, we took a number of switchbacks into the foothills of the Rhodopes, where an Orthodox convent commands

a spectacular view of Xanthi, the Thracian plain, and the blue Aegean a short distance to the south. The grand convent displays itself prominently; religion in Thrace is worn literally on one's person, to a degree unseen in the rest of Greece. After a brief respite at the convent, we continued into the Rhodope plateau, out of "traditional Greece," and into a Slav Muslim cultural zone.

Up in the high plateau, the manifestations of the Greek State were everywhere in the public realm. Public offices had oversized Greek lettering and large dual Greek and European Union flags, as if to proclaim "too much" that this is Greece. The inhabitants, their veiled womenfolk washing their landings, veiled the identity of this region, neither Greek nor strictly Turkish, nor Bulgarian. In the modern world of globalized cultures, heavy, deep state identities, religious affiliation, and mass media, the Rhodope region stands apart. The local people, known as Pomaks, have lived in the region (on both sides of the present Greek-Bulgarian border) since the arrival of the Slavs on the Balkan Peninsula, fifteen centuries ago.

The Pomaks converted to Islam later in Turkish rule, during the seventeenth and eighteenth century from a previous Orthodox affiliation. Like other Balkan populations, they chose the religion of the conqueror and became Ottomans, based on the millet system that governed the Ottoman Empire. Curiously, the region, like Bosnia, had a considerable Bogomil[28] following in the twelfth century, and it is unclear if their experiences with this heresy influenced their conversion to Islam. The Pomaks were also noticeably fairer haired and skinned than their Greek, Bulgarian, or Turkish neighbors, more resembling Poles or Czechs than South Slavs. The Greek state, as an inheritor of the *millet* system equating religion with nationality, provides schooling to the Pomaks in Turkish, and thus assists in their total assimilation as Turks.

Continuing on the high road back to Greek Macedonia, we finally reach Stavroupolis, on the Thracian side of the Nestos River, where suddenly churches and European clothing proliferate and the veiled woman is conspicuous by exception. Winding down toward the Nestos bridge, we once again depart Thrace and re-enter Macedonia, and the ethnically pure Greece that most of us associate with reality. Climbing

[28] The Bogomils were a dualist heresy that gained many adherents in Medieval Bulgaria and Bosnia. Further west, in France, they were known as Cathars.

over the mountains toward Kavala on the Aegean, all of the villages are Greek, with squat churches and coffeehouses. Not a minaret to be found.

This was not always the case in Macedonia, or indeed anywhere in Greece, or Serbia, or Bulgaria. Orthodox were always the vast majority in most parts of the Balkans, but Muslims inhabited nearly every corner of the Balkans during the Ottoman and early post-Ottoman era. Some were Turks transplanted as military or settler colonies, such as the Turks of Komotini or parts of Bulgaria. Others, such as the Pomaks or the Bosnian Muslims, and the majority of the Albanians, are local Balkan peoples who adopted (for a number of reasons) the faith of the conqueror. Thrace provides a glimpse of a former multiethnic Balkans now largely vanished from Greece, vanquished by the politics of national identity and ethnic uniformity.

Chapter IX

Romania in Parts

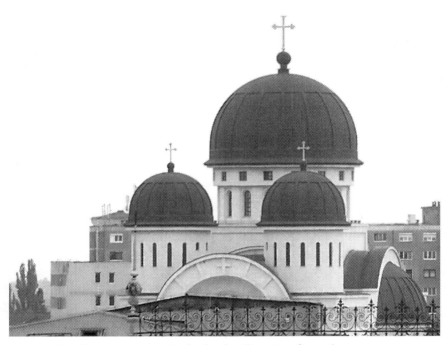

Arad's massive, new Orthodox basilica rises from the concrete Communist structures and Austro-Hungarian architecture of the city, a stamp of Romanian Orthodoxy in a multiethnic Transylvanian city. Photo by Alexander Billinis.

Bucharest, like Sofia, reminds me of Athens, though in a more acute form. Architectural gems of an earlier period, which earned the city the sobriquet "Paris of the East", have either fallen to the wrecking ball or suffer in the shadow of Stalinist concrete buildings. Gardens and Hapsburg-style cafes with flashes of baroque or secessionist architecture remind that the Danubian monarchy was not far away, and that Romanians, like all southern peoples, are voracious coffee drinkers and people watchers. These shrinking oases, like those of Athens, offer a respite from the concrete, the bad sidewalks, and the tyranny of the automobile on roads designed for carts and for an occasional Communist party member's limo, but not for mass traffic.

As ever in my travels to Balkan countries, a church sets the scene, in this case not the seat of the Romanian Patriarchate, but a lovely Orthodox church set in the Romanian *Byzance après-Byzance* style. Like the world heritage monasteries in Bukovina, northern Romania, the church's iconography was on the outside, and the inside. The brickwork, the delicate, domed cupola, and interior provides a fine example of Romanian post-Byzantine architecture. The dedicatory plaque in front of the church recalls its benefactor, a Romanian *Hospodar*, the Romanian name for the semi-autonomous Ottoman-era rulers of Wallachia, the southern part of modern Romania. Tellingly, though the dedication is in Romanian, the alphabet is Cyrillic, linking, further, the Romanians to their Slav Orthodox neighbours, the Bulgarians and the Serbs, who converted them to Byzantine Christianity.

Like the aforementioned parks, the church is a spiritual and architectural oasis, flanked by concrete monstrosities with small windows like prison cells, built during Ceaucescu's rule. The late dictator was a semi-educated peasant from one of Romania's most backward provinces. Combined with communist gigantism and general disregard for culture and aesthetics, this highly disturbed peasant from a culture stunted by the Ottoman legacy and capricious corruption and violence produced a predictable result in architecture and in society. This is why the fall of Communism was so violent in Romania, because of the years of pent up rage and stress had few parallels even among other Communist societies of the late twentieth century.

Post-Communist Romania has enjoyed a considerable wealth and investment boom, particularly in recent years, as European Union membership became a distinct possibility, and in 2007 a reality. This development, however, is distorted and overly based on consumption due

to decades of pent-up economic demands, real and aspirational. Again, the parallel to Greece is obvious and instructive, as well as predictive of future events. The sucking sound of the capital, Bucharest, like Sofia and Athens in their respective countries, pulls in all of the resources, talent, and shock-urbanized peasantry of the entire country.

As with Athens in the last thirty years, a bit of relative prosperity has been invested in wheels, driven with scant regard for the law or for pedestrians, and without the roads necessary to accommodate them. Following "Byzantine Commonwealth" patterns, Greeks were among the first foreign investors; Greek banks and companies are ubiquitous in the country, as in neighbouring Serbia and Bulgaria. In more recent years, German, Italian, and Austrian investors have made their presence felt in various industries and services, so much that few "native" companies survive.

Romanians like to point to their Latin language as their connection to the West, particularly to the French and Italians. Nineteenth century Romanians abandoned the Cyrillic alphabet of their faith for the Latin alphabet of their Latin "brethren." Romanian is indeed a Latin language but so many of their words are Slavic, Greek, or Turkish in origin, starting with the word for "yes," a very Slavic "*Da*." Further, Romanian articles are attached as suffixes to the end of a noun, a Thracian linguistic artefact that also forms part of the grammar of Slavic Bulgarian. All things considered, the Romanians are very much a product of their Balkan surroundings.

In an utterly technical sense, Romania, nearly all of which is north of the Danube, lies outside the geographical Balkans, but its Orthodox religion and culture make it very much a part of the Balkans. In a similar vein, Romania never formed part of the Byzantine Empire, but it is nonetheless quintessentially Byzantine. The Bulgarians conquered the Romanians for a time and the Latin-speaking inhabitants accepted Orthodox Christianity from them, and in so doing assimilated all of the cultural trappings of Byzantium, including Orthodoxy and the Cyrillic alphabet. The Latin-speaking element, moreover, while introduced by the Romans, cannot be considered a Western import into the Balkans, as Latin (Vlach) speaking enclaves exist throughout the Balkans. For a time, Romanian princes, such as the (in)famous Vlad the Impaler, known to the world as Dracula, fought to stem the Turkish tide over the Danube River. Though his means against the Turks (and his own subjects) earned him his infamous name, he is a hero to Romanians and by extension to other Balkan peoples for his attempts at stemming the inexorable Turkish march into Europe.

Efforts of Wallachian leaders such as Dracula or Ion Huneadora, known better by his Hungarian name, Janos Hunyadi, to keep the Turks at bay technically failed, but the Turks allowed the "Danubian Provinces," Wallachia and Moldavia, a degree of autonomy under native or appointed princes, Orthodox in religion but tributary to the Ottomans. In the sixteenth century, control of these provinces passed from native princes to the Greek (or Byzantine) families of the Phanar District of Constantinople. This clique of wealthy merchants or high Orthodox ecclesiastical officials, Greek-speaking but often Romanian, Albanian, Slav, or even Italian in origin, dominated the choice of Patriarch of Constantinople and the high posts of the Church. They also secured, in the sixteenth and seventeenth centuries, the position of Prince, or *Hospodar,* of the two Danubian Provinces. These rulers owed their position to bribery of the Ottoman Sultan and other officials, and they then sought to recoup their investment by milking the rich lands of Moldavia and Wallachia, and, as usual, their poor peasants. This pattern of selling the state to the highest bidder, and then recouping this investment, still thrives in today's Balkan countries, as all of them rank extremely high on corruption indices.[29] Habits of centuries become ingrained in local character, and regardless of the political system, the culture of corruption permeates in Romania as in the other states formerly under the Ottoman realm.

Romania's princes did manage to keep the Turks out of the peoples' day-to-day lives, and an aristocratic class of landowners remained in Romania while it disappeared in other ex-Byzantine states. The landowners often built large estates similar to those found in Russia or Poland, growing wealthy on extractive practices visited upon a peasantry basically living in conditions of serfdom. At times, they patronized the arts and endowed ecclesiastical edifices, most specifically the world-famous painted monasteries of Bukovina, in the extreme north of the country. The agricultural wealth of the "Danubian Provinces" attracted immigrants from other parts of the Ottoman Empire, most specifically Greeks but also Bulgarians and Jews. Most were merchants but the flow also included artisans, such as iconographers. The Romanian peasants, tied to the land, viewed these merchants with disdain but the Greeks and Bulgarians had

[29] According to corruption watchdog Transparency International, in 2009 Greece, Bulgaria, and Romania were tied for the worst corruption indices in the European Union. In 2010 rankings, Greece took top spot, "surpassing" both Bulgaria and Romania. No mean feat, that.

a common religion and culture with the Romanians and often married into local houses of all classes, whereas the Jews were kept apart both by profession and by religion, and set the stage for an anti-Semitism whose viciousness was without parallel in the Balkans.

Romania's experience in semi-autonomy in the two provinces of Wallachia and Moldavia is rather mixed. Rather than Turkish oppression first-hand, the heavy, often capricious, usually corrupt, hand of rule fell to locals or to Orthodox appointees from Constantinople. They would often be called "Baptized Turks," for their apparent indifference to their coreligionists. The underlying culture was still rapacious and Medieval, whereas, across the Carpathian Mountains, a new way of looking at the world was emerging.

Where the East meets the West . . .

Like their Serbian neighbours, a portion of the Romanian nation lived within the Danubian Monarchy. Romanians west of the Carpathian Mountains lived under Austrian and Hungarian rule until the Romanian kingdom incorporated Transylvania after World War One. The Romanians' experience under the Hapsburg monarchy was tantamount to serfdom, in contrast to the Serbs' generally more positive experiences under Austro-Hungarian rule in Vojvodina. The difference was fundamental; the Serbs lived in Vojvodina "under contract," with duties to the Austrian sovereign, but with defined religious and community rights. The Romanians had none of the privileges and all of the duties, and the Hungarians, in particular, kept the Romanians in servitude and the Orthodox Church under conditions of extreme duress. Like the Greeks in Southern Italy, the Romanians practiced Orthodoxy either at sufferance, or nominally accepted Papal authority and became Uniates. Transylvanian Romanians thus lack the communal spunk of the Vojvodina Serbs, assertive participants in and defenders of the Hapsburg realm, and their religious and communal rights. Romanians for centuries lived under a foreign thumb, and Austrian rule, exercised by Hungarians primarily, bore down on them with great weight.

And yet, Transylvania relative to the rest of Romania was—and is—considerably more developed economically and culturally. Landowners were no less rapacious in the Danubian Provinces, except there a peasant had the privilege of being oppressed by one's own nation and coreligionist.

Beyond the generally regressive Hungarian gentry, the civic administrators and artisans were most often Germans, as in neighbouring Vojvodina. Aloof, sober, and generally honest, the Germans managed and administered Transylvanian cities such as Arad or Cluj with a civic-mindedness that benefitted all, including the most oppressed classes, and their civic culture filtered into the Hungarians and Romanians. In this sense, Transylvania was a continuation of the successful settlement of Vojvodina. In parts of Transylvania contiguous to Vojvodina, one senses the common culture and civic mindedness of the populations. Further, Serbs, Romanians, and Hungarians live in both countries to this day.

In Transylvania German settlement was in depth, and beyond just administrative colonies. The Saxon population had been in Romania well before the Turkish arrival, invited by various Hungarian rulers to work the Carpathian mines. They formed insular, self-sufficient communities, and despite their separation from central Germany by over 1000 kilometres, kept in touch with trends "back home." As a result, most of the Saxon community became Protestant during the Reformation, and at times Transylvanian Saxons were on the cutting edge of religious and cultural change, an island in a rather regressive sea. Other Germans came from Swabia, as administrators for the Hapsburg Monarchy. They were primarily Catholic and their communities, though much reduced due to various waves of emigration to Germany, remain in Romanian Transylvania.

All of these trends had a profound impact on the local majority, the Romanians. Pressure to conform to at least the letter, if not the spirit, of Catholicism led many Romanians to become Uniates, Eastern Rite Catholics.[30] The Uniate Question is one that provokes great anger in those nations, such as the Ukrainians and Romanians, where the movement had considerable power. I remember once receiving an earful, from a rather florid Chicago Ukrainian-American florist, when I asked if he was a Uniate, rather than Orthodox. "What? Do you think I'm a traitor?" The Uniate movement among Romanians represented a compromise with the facts on

[30] Uniates, also known as Eastern Rite Catholics, Byzantine Catholics, or Greek Catholics, keep most aspects of Orthodox liturgy and dogma (including, for example, married priests) but recognize the Pope in Rome as the head of the church. Uniates are often found in areas where an Orthodox population lived at sufferance under Catholic rule for an extended period of time, such as Transylvanian Romanians, Western Ukrainians and Belorussians (who lived for centuries under Polish rule, and in pockets of Southern Italy and Sicily.

the ground, and nominal submission to the Pope removed the chokehold on the Church, which then practiced freely, in Romanian, and supported the development of the Romanian element in Transylvania. Lacking the military-colonist status of the Serbs, it was the best the Romanians could do, and meant that their community began to advance in their native land. When Romanian rule arrived after World War One, a great proportion of the Uniate population returned to Orthodoxy.

Transylvania Romanians welcomed the arrival of Romanian army and their incorporation within the Romanian kingdom after World War One. The Hungarian legacy was harsh and one that they were happy to lose, but they did not want to lose the civic and cultural benefits of the Austro-Hungarian civilization they had to a great extent assimilated. The Romanians from the other side of the Carpathians lacked an understanding of the Transylvanians' local culture and treated the area to some extent as occupied territory. The Romanian kingdom, like other emergent Byzantine states, centralized the state around the national capital wherefrom political, economic, and cultural powers were to flow. The problem was, in spite of the Romanians being one Orthodox nation, they differed considerably in culture and economic development. The less developed part essentially annexed the more developed part, and, to a degree, divided its spoils among people from Moldavia and Wallachia, rather than empower local Transylvanians. Moreover, liberation was followed by an economic slump; Transylvania was a functioning part of a large, more developed Danubian economy, and barbed wire and mistrust shut off the Transylvanians from their key markets as well as from the hated Hungarians. The economic prospects in trade with the rest of Romania could hardly compensate.

For over eighty years, Romania has been in the grip of some sort of statist economic and political environment, and Transylvania has remained as an ornate but decaying appendage to this centrally planned and controlled society. Romanian Communism became the corrupt domain of one family, the Ceaucescus. This ignorant peasant had all of the viciousness of the worst of the Ottomans with none of their subtlety. While the rest of Europe began to shed Communism in 1989, it took a violent revolution to rid Romania of its Stalinist-Ottoman Dracula.

It began in Transylvania, in the city of Timosoara, as the population protested the removal of a Protestant Hungarian pastor. It quickly spread to Arad, a neighbouring Transylvanian city with similarly mixed population. The government brought in troops and thugs from Ceaucescu's home

province to help quell the protests, but the spark from Transylvania ignited the powder keg in Bucharest. The only violent revolution in 1989 ended with the death of the dictator and his hated wife, and the installation of a clique of Communist-era pashas. In spite of the heavy corruption of the successor regimes, a key problem to this day, Romania has come far and from 2007 is a member of the European Union.

My son's godfather is an Orthodox Romanian, from the Transylvanian city of Arad. His wife, also a native of the town, is a Catholic German, descended from the Swabian colonists brought to administer the area for the Austrian Emperor. Their lovely city belongs to the same cultural and architectural milieu as my wife's Vojvodinan hometown of Sombor. Neither city has much in common with their national capitals, Bucharest and Belgrade respectively. Orthodox rub shoulders with Catholics comfortably in both Sombor and Arad; there is a considerable Hungarian population in both towns. Lacking any facility in Romanian, I found my scattered knowledge of Hungarian quite useful in Arad, and I spoke with my son's godfather's parents primarily in Hungarian. In Arad, there is a pride in Orthodox Romania, but a desire to be themselves, products of their Transylvanian environment.

While Arad, with 200,000 people, is a relatively small city, one also feels the depth of the Byzantine legacy, here in direct spiritual and civic competition, if not confrontation, with the Western legacy of Austria-Hungary. Again, a church is the primary vessel and reference point of this confrontation. Like in neighbouring Serbian Vojvodina, churches in Transylvania traditionally conformed to Western ecclesiastical styles, baroque or rococo, regardless of the faith in question. My son's godfather showed us his baptismal church, a stately yet thoroughly baroque structure similar to Orthodox churches in Serbian Vojvodina, or in the Venetian-inspired Ionian Islands in Greece. Another church, still in completion, is Arad's giant Orthodox basilica, dominating Arad's skyline and at the terminating point of the city's main street. Neo-Byzantine, domed, immense, and just slightly garish, it serves as a highly declarative cultural and political stamp of Orthodox Romania on a diverse Transylvanian landscape, towering over other buildings.

Transylvania, so long the backwater, is now Romania's border with the West. Tensions with Hungary over the Hungarian minority still exist but are mellowed with a common Europe looking over the shoulders of both countries. As for other EU countries further west, the existence

of a Brussels "watchdog" helps to safeguard the rights of minorities. Transylvania is being reintegrated with the Danubian economy, and Austrian, Hungarian, Italian, and German investment flows in, or, in some cases, returns. Sometimes a Romanian-born Saxon or Swabian who knows the country well will manage German firm's Romanian subsidiary. The faded facades of baroque Arad, Cluj, or Oradea, scarred by Stalinist concrete or statist neglect, are beginning to come out of the soot. The local Romanians, like the Serbs of Vojvodina, are well-poised to unite their Danubian and Byzantine cultures for the benefit of all.

Alex Billinis

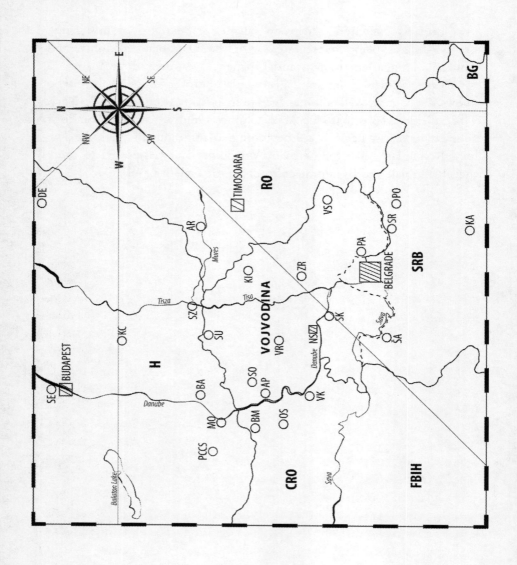

VOJVODINA MAP

H Hungary
BUDAPEST
DE Debrecen
BA Baja
SZ Szeged
MO Mohacs
PEC Pecs
KE Kecskemet
SE Szentendre

RO Romania
TIMOSOARA
AR Arad

CRO Croatia
BM Beli Manastir
OS Osijek
VK Vukovar

SRB Serbia
BELGRADE
SO Sombor
AP Apatin
VR Vrbas
NS Novi Sad
SK Sremski Karlovci
SU Subotica
KI Kikinda
ZR Zrenjanin
VS Vršac
SA Šabac
SR Smederevo
PO Požarevac

Vojvodina Map

Chapter X

Austrobyzantinism: Vojvodina

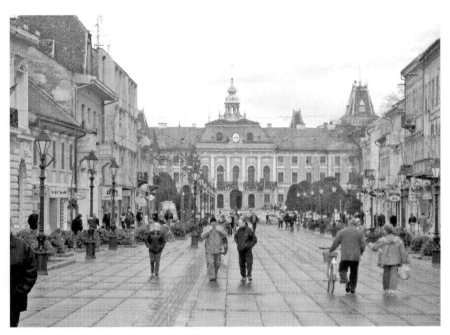

Sombor Prefecture building, a masterpiece of late Austro-Hungarian administrative architecture, on a Fall day as seen from Sombor's King Peter Street pedestrian zone. Photo by Alexander Billinis.

Vojvodina, perched on the edge of the Byzantine world, in the fertile Danubian Plain, in physical, architectural, cultural, and human geography is a true borderland. An autonomous province of the Serbian Republic, Vojvodina reflects a transition zone between the Austro-Hungarian cultural realm, an Eastern salient of West European civilization, and that of the Byzantine, the Eastern Christian successor to the universal Roman Empire which in only in the past two centuries re-emerged from the deep freeze of the Ottoman legacy. Over twenty nationalities call Vojvodina home, and most have both deep local roots in the area and a belief in their distinctiveness from their co-nationals outside of the region. The writ of Belgrade is less in evidence here, unless it overly declarative in a way that expresses its relative distance from Vojvodinan hearts and minds.

Vojvodina's very name derives from *Vojvoda*, a term for military commander, and the foundations of this distinct border society have their origins in the incessant warfare between the Ottoman Turks, coming up from the south, and the Austrian-led Western Christians, pushing the Turks back from the north and west. Thus, to understand the area, the first thing the traveler ought to do is to visit several sites, which provide a historical context to the demographic and architectural reality we find today.

The lower Danubian plain for centuries before the Turks arrived in the 1500s had been an area of both peaceful and violent confrontation between Serbs and Hungarians, and Hungarians at various times possessed Belgrade even as Serbian authority, and the flagships of Serbian culture, Orthodox monasteries, appeared north of the Danube, prior to a violent surge from the Southern Balkans which swept all before it. These new invaders had origins in the desert fastness of Mongolia, just as other Asian invaders before them, including the Europeanized and Christianized Hungarians and Bulgarians. They employed the same horse-powered tactics as previous Asiatic tormentors of Europe, but they differed in key ways. They were backed by the most advanced military technology of the time, combined with the religious, ideological and ethical cohesion of Islam. They readily absorbed the institutional systems of the Byzantines and other advanced states they conquered. Having swamped the Balkans, the Turks turned their mobile war machine on Hungary.

Not more than five kilometers from Hungary's southern border with Croatia and Serbia, and well within sight of the Danube, lies the field of Mohacs, where the youthful King Lajos led a battle of martyrdom as

his twenty-five thousand Hungarians fought a heroic and ill-fated battle against ninety thousand Turks, in 1526. The Hungarian monument to their dead is a chilling tower of iron recalling a suit of mail armor worn by the officers on both sides, and a death circle of several iron and wooden crosses, buried statues, turbans, carvings of mourning mothers in a style both naïve and strangely modern. The connotations of death, burial, crucifixion, impalement, and the eventual resurrection of the nation resonated throughout the memorial. The Hungarians designed a memorial to bring home the piercing horror of fifteenth century warfare and the sense of material and spiritual devastation wrought by the Turkish invader. No other battlefield I visited has had the same effect on me. Few battles, moreover, so fundamentally changed the map as this. Even in springtime, as the fertile plains sprang to life, the place felt of death.

As a result of Mohacs, a huge, productive part of Europe, the Pannonian Basin, fell under the rule of the Turk, and only two unsuccessful sieges of Vienna brought the Turkish onslaught into the heart of Europe to a close. After the second Siege of Vienna, in 1683, the Austrians led a multinational European coalition that included Venetians, Poles, Germans and assorted adventurers and mercenaries to push the Turk eastward and southward, taking Buda in 1686, removing the minarets from the skyline. In Budapest today, Austrian architecture prevails, and only some of the winding streets of hilly Buda and a few domed baths recall the Turkish sojourn.

Turkey in the late 1600s had begun to lose its steam, similar to so many states founded on nomadic warfare. The Christians living under Turkish rule, Hungarians, Slovakians, Croatians, readily aided the Christian forces, which eventually burst into the Balkans from the north just as the Venetians burst out of their island enclaves in Greece and Dalmatia from the south, in an attempt to push the Turks out of the Balkans. Belgrade fell, and on the field of Kosovo, an Austrian-led force nominally avenged the defeat of the Serbs in 1389.

From the south, the Venetians led an army composed in large part of mercenaries and Greeks against the Turks, from multiple jump-off points, and occupied the Peloponnesian Peninsula of Southern Greece, bursting into Attica. In Athens, the Turks lost the lower village that had become Athens and retreated, as so many others in the past, to the Acropolis, storing their arms and powder in the Parthenon, which survived two millennia intact. One Venetian shell changed that, and turned the Parthenon into the ruin we see today.

Alex Billinis

As the guns fell silent, the Western powers, now deep in the Balkans, brought in their wake the priests, pressuring with various degrees of abuse and severity the local Orthodox, Serbs and Romanians in the north and Greeks in the south, to accept Catholicism. It was as if nothing had changed since the 1400s. For the East of Europe to join the West, the West insisted on its terms, among which was the adherence to Catholicism. It had been a blackmail the Orthodox peoples of the Balkans refused to accept three hundred years before, and on the whole they remained unwilling.

Taking advantage of this, the Turks, far from vanquished, gathered their strength and counterattacked north and south, and for the most part Greek and Serb stood aside, knowing that the Turks, in spite of their corruption and capricious cruelty, would not (generally) interfere with the Orthodox religion so beloved of the enslaved Balkan peoples.

The Turks regained possession of Serbia and thrust themselves over the Danube once again, harassing the Austrians' new Hungarian possessions, making some of Europe's most fertile fields a wasteland. The Austrians faced a serious problem. To secure and to develop their vast conquests, they needed settlers, farmers, soldiers, and administrators. Intrepid Germans from Swabia (*Schwaben*) were willing to serve a Catholic German sovereign such as the Austrian Emperor, but a critical mass of more local people with agricultural and military skills was needed. Serbian irregulars had fought doggedly and well for the Austrians, and Serbs certainly possessed a hatred of the Turks and the desire to live in a more developed society and economy. However, they simply refused to become Catholics in order to partake, though many Greeks and Serbs who fled the Turks into the West did accept Catholicism, as did, generally, the Greek populations of Southern Italy.

Faced with the Serbs' obstinate refusal to assist the Austrians, the Kaiser struck an enlightened and far-sighted bargain. He essentially offered the Serbs in the areas bordering the Turkish Empire local civic and religious autonomy similar to what they had under the Ottomans in return for living in and protecting the military border, known in Serbian as the *Vojska Kranja* (Military Frontier), from which the name Vojvodina derives. At the Austrians' invitation, tens of thousands of Serbs, led by their Orthodox Patriarch, abandoned the Ottoman Empire for the Military Frontier, bolstering the Serbian population *in situ* and grafting their Serbian Orthodox identity onto a relatively enlightened civic and intellectual environment.

Never before in the long history of Orthodox-Catholic relations had a critical mass of Orthodox people lived in a Catholic-controlled territory with their religious and community privileges intact and respected. The Serbs bargained well to protect their community identity while removing themselves from the stultification of Turkish rule, which arrested the development of their fellow Serbs south of the Danube and the other Balkan Orthodox peoples. Through luck, tenacity, and spirit, these northern Serbs received the best of all worlds. The Serbs "rejoined Europe," but on terms which preserved their identity. In contrast, the Greeks under Venetian rule in Peloponnesus and elsewhere were constantly pressured to convert to Catholicism, and thus did not support the Venetians against the Turks. They regained the Peloponnesus, and the province sank again into the Ottoman Empire.

The frontier situation stabilized fully in the years following the Treaty of *Sremski Karlovici* (Karlowitz), signed in 1699 by the Ottomans, Venetians, and Austrians, on a hillock now dominated by a Roman Catholic chapel, built later to honor the site of the treaty's signature. After the Treaty of Passarowitz, signed in 1717, The border between East and West lay along the line of the Danube and Sava Rivers, south of which the Ottoman realm went in full decline though not yet in full retreat. Though raids were conducted across the line periodically, fortresses such as the vaulted Petrovaradin, overlooking Novi Sad on a bend of the Danube River, assured that the Turks would never again pose a threat to Central Europe.

Petrovaradin crowns the south bank of the Danube, on high ground across from Novi Sad. A classic example of seventeenth century European military architecture, the fortress today overlooks the beautiful city of Novi Sad on the north side of the Danube, crossed by a brand new bridge built to replace one "removed" by NATO bombings in 1999. Last time I visited, on May Day 2008, the fortress was decked out in awnings and flowers, as Serbs celebrated the day off in spectacular weather. Often the same sites chosen for military value also are quite majestic and romantic, and I have seen the view from Petrovaradin with my wife during our engagement at sunset, which certainly is a stirring spot. We had just completed a tour of the dank insides of the fortress, with a quasi-official tour guide, a history student who milled about the place. For a coffee and the equivalent of three euros, he spent 90 minutes taking us through key parts of the fort, and providing answers in unsure but grammatical English to all of my questions.

I love visiting historical sites in Serbia. Here we were, in one of the most important fortresses in European history, without the long lines and conveyor belt tours, which have the effect of industrializing the tourist experience. We had the place, as it were, to ourselves, and with an educated yet inexperienced guide, the whole tour was more like an encounter, with an intimacy that let the imagination fill the fortress with ghosts of the past. That simply cannot occur when modern package tourism often resembles a bar code-scanner system. Serbia requires travel rather than tourism. Lacking the beaches of neighboring Croatia and Montenegro that seem to stereotype the notion of "holiday," or the stately cityscapes of a Paris, Rome, or New York, visiting Serbia's gems of geography, landscape, and architecture presupposes an informed quest not suited to the tourist, but rather to the traveler.

Behind Austria's sturdy frontier guarded by stalwart Serbs, the Military Frontier's economic and cultural life thrived. The rich black earth (*chernozemja*) of the area yielded bountiful harvests, and German administrators and craftsmen ensured that an honest, productive civic society emerged where before there was chaos and corruption. While towns in the Ottoman Empire were muddy lanes with occasional sumptuous houses, magnificent mosques, and architectural relics from the Byzantine and Roman past, towns on the Austrian side of the border boasted soaring baroque church spires, *Rathauser* (City Halls) every bit the peer of German and Austrian cities, sturdy *burgerlich* homes built according to codes, in towns with wide, cobblestoned streets. Architecture in Vojvodina, as elsewhere, tells tales about the inhabitants.

Orthodox Serbs formed a majority of the border population, but the area was tolerantly multiethnic, a legacy that survives in Vojvodina today. The aforementioned Germans certainly occupied an upper stratum of society, and set the civic stage, but Catholic Croatians, Hungarians, Slovaks, Orthodox Greeks and Romanians, and several large Jewish communities also thrived in the area. Whereas Jewish communities in Serbia, Bosnia, Greece, and elsewhere under Turkish rule tended to be Sephardic Jews expelled from Spain, Portugal, and Italy and welcomed into the Turkish Empire, the Jews of Vojvodina were typically Yiddish-speaking Ashkenazi Jews, as in other parts of the Austro-Hungarian Empire. The Ottoman-Austrian borderline even showed its effect on the Jewish communities.

Serbian merchants, prosperous farmers and military captains funded educational, religious and civic institutions, to the degree that the Serbian

Orthodox Church hierarchy quit the Ottoman Empire and established its Patriarchate in Sremski Karlovici. For a time, this Patriarchate had the spiritual authority over all Orthodox in the Austrian Empire, Greek, Serb, or Romanian.

To visit the town today is to combine the intellectual feel of Oxford with the Sacred of Byzantium, set among baroque Austrian architecture in a slightly hilly town where uneven, winding Balkan streets flow like tributaries to the Danube River, enervating in the summer heat. The town feels aptly symbolizes Vojvodina, with its Serbian soul and Hapsburg style. From Sremski Karlovici's academies graduated generations of Serbian intellectuals and clergy, who fostered their nation's cultural and economic advancement. When the Serbs south of the Danube began their rebellion against the Turks, Vojvodina Serbs provided military and financial aid, but above all a cultural and intellectual infusion, which ensured that the desperately poor nation that emerged, possessed an imported yet native intelligentsia to assist in overcoming, to some degree, the legacy of five hundred years of Turkish rule.

Vojvodina Serbs celebrated the fitful emergence of the Serbian Kingdom to their immediate south, and many immigrated there, yet the benefits of living in a large, generally prosperous, and relatively tolerant empire also adhered them to the Hapsburg realm. Like other minorities in the Austrian Empire, they sought greater local autonomy within the Empire, and not necessarily without. The biggest threat to the Serbs, like other Slavs, came from another constituent nationality in the Empire, the Hungarians. The Hungarians dominated the eastern and southern parts of the Empire, and sought to curb the rights of all non-Hungarians and to assimilate them. For the Serbs specifically, this curtailment of their identity essentially contradicted the explicit rights they had received from various Austrian sovereigns.

Thus, in 1848, when the social and national revolutions broke out all over Europe, the Serbs actually fought to preserve the Empire and their rights against Hungarian encroachment. Hungary's abortive attempt at independence from the Austrian Empire (and domination of Serbs and other non-Hungarians within the expansive borders of Hungary) met defeat at the hands of Austrian regulars, Russian troops, and Serbian irregulars. For a time, the Military Frontier area returned to its tolerant multiculturalism, and the Vojvodina Serbs formed, if anything, a link between Austria and the struggling Serbian Principality, whose expansionist eyes were turned

to the Serbs still struggling under Turkish rule, rather than prosperous Vovjvodina, which formed a bridge with Austria.

A series of factors conspired, as they often do in history's ceaseless flow, to unravel the implicit compact that existed. The Austrian Empire, as a prison of nations, dealt with its inmates rather benignly, but the realm had become a relic, beset upon by German unification and Italian unification, and the demands of its subject peoples, most especially the Hungarians, but also the prosperous and articulate Czechs, the fiery Poles, and the deeply oppressed Romanians. Taking advantage of an Austrian defeat at Prussian hands, the Hungarians forced the *Ausgleich* Compromise in 1867, which created the Dual Monarchy of Austria-Hungary. Suddenly the Hungarians ruled rather heavy-handedly over a Kingdom where over half the population was not Hungarian.

Serbs chafed under Hungarian domination, but Serbia, poor and small as it was, could ill afford to offend Austria-Hungary, particularly given Serbia's designs against the Turks. Serbia grew a bit further south in 1878, after a vicious war in which they met defeat, and then victory via a Russian invasion of the Balkans, which also created the basis for Bulgaria. As the embers cooled, Austria-Hungary, already creaking with too many nationalities, occupied the northwestern Ottoman province of Bosnia, populated by Orthodox Serbs, Catholic Croats, and Slav Muslims.

The occupation of Bosnia changed the Serbs' perception of Austria-Hungary from that of a protector to that of a predator who would stymie the goal of Serb unification and the nascent "Yugoslavism." Until the Turk was expelled from Europe, Austria could wait, but her occupation of Bosnia and her unwillingness to see Serbia expand to the Adriatic made certain that the aggressive Serb Kingdom ultimately would eventually and opportunistically clash with Austria.

Serbia, Bulgaria, Greece, and Montenegro pooled their military resources into an alliance more of convenience and necessity than of pan-Orthodox sentiment. This "Balkan League" threw the hammer down on the Turk and nearly expelled him from Europe entirely. Greece and Serbia met somewhere in Macedonia, and declared themselves satisfied, but the Bulgarians were not. The Bulgarians attacked the Greeks and Serbs, and the Romanians and Turks joined the Greek-Serbian axis that quickly snuffed out the Bulgarian attempt to become the arbiter of the Balkans.

Serbia now nipped at the heels of the Austro-Hungarian Empire, which had annexed Bosnia-Herzegovina from the Turks. The province, then as

now, was a cauldron of Slavs of Orthodox, Catholic, and Muslim faith, and, then as now, religion determined political adherence. Orthodox Bosnians wanted to unite with Serbia, and one of their number assassinated the heir to the Austro-Hungarian throne, Franz Ferdinand, a man, ironically, well-disposed to granting Slavs in the Empire greater autonomy.

Austria-Hungary attacked Serbia from the north and west; Belgrade after all was literally only across the Danube and Sava rivers. After a few months, they captured Belgrade, but the Serbs threw them out, and only in 1916, with German and Bulgarian help, did Serbia succumb. Its army retreated through Albania to the Adriatic, picked up by Allied ships, nursed to health on the Greek island of Corfu, and redeployed at Salonika with French, British, and Greek troops. In 1918, the Austro-German-Bulgarian line collapsed, and the Serbs returned. The Croatians and Slovenians accepted the unification of their lands under the Serbian king, and the foundations of the South Slav State emerged.

Vojvodina's tradition of tolerance remained after the amalgamation of the Kingdom of the Serbs, Croats, and Slovenes in 1918. Serbs in the region rejoiced in joining their brethren in one state, but the unitary nature of the interwar Yugoslav state grated on people with local traditions distinct from other Serbs, and the desire to keep local institutions was quite strong. The very large German and Hungarian populations shared little of the enthusiasm for inclusion in the new state, but in general an atmosphere of tolerance remained, and in any event the boundaries between ethnicities had always been fluid in Vojvodina. However, even among the Serbs, as the 1920s and 1930s wore on, many still retained a nostalgia for the old Empire, and while a popular local ditty, "I gave four horses to bring the Serbs here, and I would give eight to take them away,"[31] might be too harsh, it still showed a distinctiveness from the rest of Serbia.

The horrors of World War Two did not spare Vojvodina, though the partisan warfare lacked the utter viciousness in parts of Croatia and Bosnia. Local Germans typically enlisted and fought with the Germans, while Hungarians welcomed the reintroduction of Hungarian rule, but at times, they protected their Serbian neighbours. The Vojvodinan ethnic mosaic still remained after the war, but two ethnic groups never recovered from the war. The German communities throughout Yugoslavia were rounded up and expelled in a collective punishment for Nazi atrocities

[31] Margaret MacMillan, Paris 1919, (New York: Random House, 2001) 135.

and their often-active participation or sympathy.[32] Many Hungarians moved into Hungary as well, but there was no collective move against Hungarians; the old tolerance remained. Jews generally met the same fate as their coreligionists in elsewhere in Europe, an industrial genocide that reduced the communities in Vojvodinan cities to hollow shells of their pre-war selves. Crumbling synagogues and cemeteries dot Vojvodinan cities as testament to a nearly vanished community.

The expulsion of the Germans was the first ethnic engineering in Vojvodina since the introduction of multiple populations (including the Germans) in the 1600s. The Germans constituted an integral part of the region's ethnic, social, and particularly economic fabric. Their farms and shops ran with typical German efficiency and industry; the other nationalities assimilated their architectural legacy. In the second part of the ethnic engineering, partisan families, often from mountainous parts of Croatia and Montenegro, replaced the Germans as loyal Yugoslavs (basically Serbs or Montenegrins).

Local Vojvodinans of all nationalities describe these new arrivals as mountain peasants with little culture and totally unused to the relatively advanced German houses and farms they often received. A typical story, repeated so often, "they broke the tiles in the bathrooms, so their stock animals would not slip," implying that they lived with their animals. Whether apocryphal or not, clearly the villages emptied of Germans no longer had the scrubbed efficiency and maintenance of the past.

Outside Sombor, Vojvodina's fourth largest city one finds many of these ex-German villages. One such village is known to its former (primarily German) inhabitants as *Kernei*. In this town, now known as *Klajichevo*, large, stately Swabian Style houses reminiscent of Austria (*Shvabska kuca*) line the main road, often as not peeling and crumbling, as if the last maintenance was in the 1930s. The present inhabitants, nearly all of whom came from Montenegro and the karst escarpments of Western Croatia, behaved as if hermit crabs, taking nominal care of their "shells" but with little interest in their houses beyond their structural integrity. Towns with more rooted local Serb or Hungarian residents noticeably took better

[32] There were, however, many active dissidents to Nazism among the Yugoslav Germans, but the community, like other Germans in Eastern Europe, received a collective fate. Many did remain by reclassifying themselves as Hungarian, particularly if they were in mixed marriages, which was very common in Vojvodina throughout its history.

care of their homes and neighbourhoods, but these transplanted border colonists lacked this civic sense, owing to their disparate legacies, one of the Austrian domination of Vojvodina and the other of the colonists' Ottoman heritage.

The Socialist Yugoslavia of *Bratsvo i Jedinstvo* (Brotherhood and Unity) fit Vojvodina quite well, as the official state dogma of unity in diversity of South Slav (and other) peoples under the relatively benevolent dictatorship of Marshal Tito bolstered Vojvodina's already strong tradition of tolerance. Yugoslav identity took hold among the ethnically diverse and often individually mixed Vojvodinans. In addition to the Yugoslav identity, the locals had an autonomous provincial institution within the Yugoslav federal system, which to a degree satisfied and institutionalized their strong local identity. Individuals chose their school according to their ethnic background and wishes, and to this day on the streets of major cities such as Sombor, streets and public announcements are in both Serbian and Hungarian, and class graduation photos are in the language of the school in question, prominently displayed in storefronts. Further, Vojvodina, with its bumper crops and minor oil deposits, was among the richest provinces in Yugoslavia, and the last years of Yugoslavia are remembered with nostalgia as times of relative prosperity and harmony, as a calm before the storm.

Yugoslavia's violent breakup spelled the end of this period of prosperity, replaced by sanctions, mafias, and greater corruption, but inter-ethnic tolerance for the most part remained, and the Serbian state, so vilified by the international community, did not retaliate against non-Serbs in Vojvodina. The biggest cleavage in Vojvodinan society became that between locals of all nationalities and Serbian refugees from Bosnia and Croatia, expelled as a result of the 1990s wars. Local Vojvodinans of all backgrounds resented them for their tendency to more radical politics, and occasional xenophobia, and the refugees, having been expelled due to their ethnicity, tended to resent the greater prosperity of the sober and industrious Vojvodinans and the presence of so many non-Serbs.

Throughout war, sanctions, and bombing, Vojvodinans survived and fed the rest of Serbia. As the richest part of what remained of Serbia, Belgrade used Vojvodina to subsidize the rest of the country, which has fed local resentment and stoked autonomist sympathies. The Serbian government also encouraged resettlement of hundreds of thousands of Bosnian Serb and Croatian Serb refugees in Vojvodina, in part to alter the

demographics of the region more in favor of the Serbs. There the Serbian government remained true to its Balkan antecedents. Greece ethnically engineered its northern borders with Greek refugees from Turkey and Bulgaria in the 1920s, and in the 1990s, Greeks repatriating from the former Soviet Union received encouragement from the Greek authorities to settle in the province of Thrace, where a large Turkish minority lives.

Today Vojvodina lives in a netherworld, *"Ni na nebu, ni na zemlji"* (neither on heaven nor on earth), as the Serbians say. With neighboring Romanians, Bulgarians, and Hungarians in the EU, the self-sufficient and industrious Vojvodinans say, "why not us?" They have a sense of nostalgia for the old Yugoslavia, with its relative prosperity and ethnic harmony, when being in between East and West was an advantage their neighbors lacked. While they share a sense of anger and injustice at the vilification of Serbs and the amputation of Kosovo, they also believe that Belgrade is corrupt and bleeds Vojvodina. Almost subconsciously and guiltily, they wonder if they, too, could become independent, and with their Western values of industriousness and thrift, become prosperous quickly. They cling to their dual identity as soulful Byzantine Slavs, and thrifty, industrious Hapsburgs.

Walk along the Danube River promenade of Apatin. The city used to have a large German population and its Catholic Cathedral and *Gradska Kuca* (town hall) are architectural models of Austro-German baroque architecture every bit at home in Bavaria or Wisconsin, both of which, incidentally, are home to many of their German former inhabitants. Nearly all of the present population are Serbs, either locally rooted Vojvodina Serbs, post-World War Two migrants, or recent Serb expellees from Croatia and Bosnia. They want to be part of their common European destiny, yet they want to drive the same bargain as the Serbs of old in Vojvodina, or as the Greeks, and the Romanians and Bulgarians, now in the European Union. They want to join the European Union as proud Orthodox Serbs, while knowing that their Austrian heritage has given them advantages, which, if allowed full expression, will bring them prosperity. Back on Apatin's Danube boardwalk, a brand new Orthodox Cathedral faces Croatia. Unlike traditional Vojvodinan Orthodox Churches, its architecture is neo-Byzantine, with blood red, pattern bricks and rising domes a modern version of the martyred Kosovo Churches. In fact, like in Romanian Transylvania, all of the new Orthodox churches in Vojvodina are neo-Byzantine, rather than baroque, crying out, architecturally, that "this is Serbia, we are Orthodox, we are Europe." Will anyone hear?

Apatin Basilica, of recent construction in a Serbo-Byzantine style typical of southern Serbia as an architectural and religious stamp of Serbian Orthodoxy in a multiethnic Vojvodina. The Basilica faces the Danube River and Croatia. Photo by Alexander Billinis.

Chapter XI

Belgrade: Byzantium's Gate

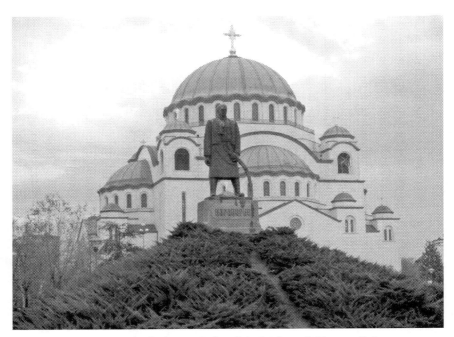

St. Sava Cathedral, on Belgrade's highest hill, a religious and cultural monument to Serbian Orthodoxy clearly and deliberately linking Serbia with Byzantium. Statue of Karageorge, Serbia's guerilla liberator and founder of the Karageorgevic Dynasty, stands in the foreground. Photo by Alexander Billinis.

Geography is destiny. Situated at the confluence of the Danube and Sava Rivers, at the edge of the hilly Balkans and the fertile, vast, Pannonian Plain, Belgrade has always figured centrally in commerce and conquest. Geographic factors predetermined that Belgrade would become a great city and fortress, long before humans recognized the obvious and built settlements there.

Geography accentuates the dual (and dueling) sensations of proximity and distance in Belgrade. The city is so close to Central Europe geographically, yet so far away, culturally. Despite the distance from Salonika, Belgrade more accurately resembles the Aegean metropolis in terms of feel and culture than it does Central European towns just across the Danube in Vojvodina, even though it is now the same country. In World War One, the Austro-Hungarian army, when besieging Belgrade, had its forward positions just across the Danube and Sava Rivers, and took a year and two invasions to subdue the city. So close, yet so far away. Belgrade is a vibrant European city, close in proximity to the heart of Europe, yet its mindset, stoicism, and culture make the city seem far away from other Danubian towns further up the river.

Borders and shading always fascinate me, and Danubian, Balkan Belgrade, is both a frontier and a center. These kinds of places often foster creativity among the inhabitants, and a built-in cosmopolitanism. Such places also foster a certain insecurity and "declarativeness." Thus, Belgraders (*Beogradjani*) will emphasize, in word, deed, and architecture, their modernity, their Western-ness, and at the same time, their distinctive, Byzantine identity. Their location points them toward Central Europe, but their hearts yearn for Byzantium. Two Belgrade landmarks, most appropriately Orthodox churches, provide an illustration.

The Serbian Patriarchal Church is a lovely baroque structure similar to the churches across the Danube, in Serbian Vojvodina, and baroque churches throughout Central Europe and beyond. This church presents a distinctly Western orientation, which makes historical sense when one remembers that the Serbian Patriarchate and Church hierarchy fled the Ottoman Empire to Austrian-controlled Vojvodina, before returning to the Serbian principality after they wrested autonomy from the Turks. The church is compact, rational, and comfortable, with ornate baroque facades and iconography heavily influenced by Western norms. All told the church presents the supplicant with a *gemutlich* Central European feel, one that fits with part of the Serbian national odyssey. That said, in my

(admittedly biased) opinion, the rational and more angular lines of this house of worship do not convey the mystery of Orthodoxy fully.

In contrast, St. Sava Cathedral, with its "St. Sophian" domes and magnitude, functions as a more complete vessel for the enormity of the Orthodox faith. The St. Sava Cathedral is venerable, yet not old. In fact, it awaits completion. The foundations date from before the Second World War, but when I saw it the first time, in 2002, the cathedral, though magnificent, was still exposed with concrete facing. In February 2004 I visited again, first approaching in twilight as the winter sun bathed it in a shimmering yellow-red—the white marble facing was complete. We talked our way into the interior, still unfinished concrete, but with a dome so soaring and celestial, so reminiscent of our lost Orthodox temple on the Bosporus. With tears in my eyes, I recalled the words of the pagan Rus envoy upon witnessing St. Sophia: "we did not know whether we were in heaven or on earth." Even without frescoes, the majesty of St. Sava Cathedral evokes similar platitudes. Having seen the actual St. Sophia in Istanbul, St. Sava's clear descent from the holiest of Orthodox shrines is obvious, deliberate, and nonetheless fully integrated into its surroundings.

My wife immediately compared Belgrade's feel to that of Salonika, and truly there exists a real similarity between the two Orthodox cities. The style of buildings, the features of the people, and even the preference of sartorial styles exhibit a remarkable similarity, as if a river rather than the expanse of several hundred kilometers separated the two cities. They do, however, share a common culture and religion, and this Byzantine identity, incorporating both Slav and Hellenic elements, makes the denizens of each city feel at home in the other. The similarities of the two cities are a good example of the victory of culture over geography.

When we visited Istanbul, the topographical scene even more closely resembles Belgrade, with the narrow channels of the Bosporus and the Golden Horn harbor substituting for Belgrade's hilly Danube and Sava river confluences. Hills, winding streets, forts, cafes, churches, all point to membership in a commonwealth that spanned well over one thousand years, under its Byzantine, Ottoman, and Serbian auspices. Belgrade is the northern gate to this incredibly profound Byzantine-Ottoman zone.

The key to the Gate of Belgrade, then as now, is Kalemegdan Fortress. Located at the exact joining of the Danube and Sava Rivers, the site has been in continuous use since prehistoric times, offering as it does a

command of the river traffic. Like hermit crabs, the various dominators of Belgrade occupied the site of their successors to create a fort with Roman, Byzantine, Turkish, and modern emplacements. Serbia wrested its autonomy from the Ottomans in 1830 but only in the 1860 did the Turks hand over the keys to the fortress to the Serbs, an event commemorated in a small plaque on the fortress grounds. Sites chosen for strategic vantage in war and commerce are often romantic in peace, and like Petrovaradin in Novi Sad, Kalemegdan in late summer, with the hint of autumn breezes, gardens, and the ubiquitous cafes overlooking the combination of two massive rivers, stirs the strings of the heart as well as those of the intellect. In Serbia, I believe that the romance is deeper because historical and cultural monuments are not subjected to the conveyor belt of mass tourism. A traveler in Serbia has the opportunity for greater intimacy with the surroundings than in more visited destinations.

I have generally approached Belgrade from the flat north, from the fertile fields of Serbia's Vovjvodina province, already in Central Europe, where two dozen nationalities live, and in spite of the province's Serbian Orthodox majority, and its separation by only a river from Belgrade, immediately the atmosphere changes from Byzantine to Habsburg, the towns, architecture all conform to the norms of Vienna and Budapest. On the edge of this Habsburg cultural zone, Belgrade readily absorbed much of its culture, even as Serbians in Austrian Vojvodina planted their Orthodox culture firmly in Central Europe.

This dueling duality—in edifice and culture—makes Belgrade an interesting place to discover, and the city becomes more interesting the more you get to know it.

Walking Belgrade's streets and pedestrian zones, rarely level but subject to the undulation of the underlying hills, slightly chaotic in structure, its cafés are full. It is a city where the cuisine edges toward Austria and the cafés alternate between Balkan and smoky, Austrian and *gemutlich*, and a global trendy with the latest in music, media, and fashion. Like all Southern peoples, *Beogradjani* take their cafés very seriously and favorite haunts for types and occasions abound. Nightlife? Again, think Southern. Everything you will find in Greece, the same music, spirits, dancing on the tables, yet with doses of Habsburg eclectic and alternative "scenes" rarely in evidence in Athens and only hinted at in Salonika. There is also a greater intellectual brooding about the city, and a tendency towards gloom and depression singularly lacking in Athens. Here geography takes

precedence. Greece is a land of sharp sunlight and the calming effects of the sea; the sun does not shine the same way in Serbia, and Serbia lacks a coast. Further, the Danubian basin to the north is noted for its brooding peoples of all nationalities, even as their artistic and intellectual talents are world-renowned. Belgrade inherits from both, and the more you know the city and its denizens, the clearer this becomes.

The comparison to Greece is indeed becoming more and more apt. Belgrade, once a lovely city like Salonika or Athens of old, now seems to embrace the culture of concrete and credit. At times, when navigating the streets of Belgrade, I feel the confusion and annoyance that Fermor must of felt as his beloved Athens met the wrecking ball for faceless concrete blocks, already slummy by the time they were finished.

And yet, like Athens, Belgrade still has its gems. Walk down an alley just off the bohemian Skadarlija quarter, the street steeply sloping towards the Sava River. There we found a fresco gallery affiliated with the national museum. The attendant did not charge admittance, and we entered a series of vaulted rooms filled with replicas of frescoes from Serbia's innumerable monasteries and churches, precious relics of Serbian past history and present passion and plight. At plaster a bookish fellow painted, painstakingly replicating frescoes from a Kosovo monastery. We spoke briefly, and in spite of his humility, his talent and pride shone through his work and diction. Like so many extensively educated Serbs, there was less in the business world to offer him (though this too is starting to change), and so he turned his talents to something greater and longer lasting that the quarterly figures that govern most of our lives. His work will continue to inspire long after earnings figures become old news. This is the Belgrade I love, and it is in danger of oblivion.

Chapter XII

Smederevo and the Heart of Serbia

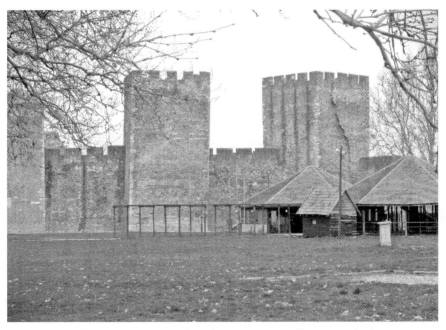

Smederevo's Inner Castle, whose strong walls succumbed to the Turks in 1459, extinguishing the last vestiges of Serbian independence for four hundred years. Photo by Alexander Billinis.

Alex Billinis

The route from our home in Sombor, in Serbia's Austro-Hungarian influenced extreme northwest, to Smederevo, the heart of today's Serbia, could be covered in two ways. If you had a boat, the entire trip could be made by the Danube River, as Smederevo's Serbo-Byzantine walls abut the Danube, and Sombor is a mere 20 kilometers from the river. Such a trip using the oldest highway in these parts, the mighty Danube, is truly a leisurely and a romantic way to view history and civilization. However, as a 21st Century dad with schedules and children, it made more sense to drive. Travel is a series of choices. It became clear that, while my travelogue of Byzantine Europe today will never be complete or comprehensive, some sites *had* to be visited. Smederevo is one such place.

Driving through Serbia, particularly on the North-South autobahn, I often find myself drifting back to America. Much of Serbia readily reminds me of America, whether the flat fertile plains of Vojvodina recalling Illinois or Missouri, or, especially the rolling wooded hills of Sumadija, Serbia's heartland. Sumadija itself means "the forest land" in Serbian, and the rolling, verdant hills readily recall Ohio or parts of Pennsylvania and Kentucky. Again, speeding by on modern roads, you can imagine yourself in Middle America.

Except for the cities, of course. While Belgrade, a mixture of Byzantine, Austrian, and Ottoman influences, could hardly be imagined in America, some of the smaller hamlets and farms are not that different. Indeed, in the past, during the same time that Americans like Abraham Lincoln were splitting log rails and building log cabins in Kentucky and Illinois, their Serbian contemporaries were doing the same thing, as Balkan historian Leften Stavrianos elaborates:

The manner of everyday life in Serbia closely resembled that of the Ohio Valley—the same log cabins, home-made furniture and clothes, plain food but plenty of it, plum brandy in place of rum . . . Serbia was an egalitarian, rough-and-ready frontier society, knowing neither poor men nor rich. Foreign observers reacted to Serbian peasants in very much the same way as frontiersmen of the New World.[33]

[33] L. S. Stavrianos, The Balkans Since 1453, (New York: New York University Press, 2000), 251.

Some of that down-to-earth, meat and potatoes, almost American attitude remains to this day, which makes a visit to interior Serbia a very down-home experience, particularly when combined with the Eastern penchant for hospitality.

While Serbia had the "physical appearance of an American frontier region," it possessed the cultural characteristics reflecting the past centuries of Ottoman rule."[34] The first prince of Serbia, Milos Obrenovic, in act and deed was not much different from a Turkish pasha, except that he was a Serbian. However, to suggest that Serbia is nothing more than a Christian Ottoman successor state would be quite unfair. That there are elements is certain, and that this has arrested Serbia's development to this day is also true, but it is far from the whole story.

First of all, the Serbs possessed a highly literate and economically powerful community across the Danube and Sava Rivers, in Austrian-ruled Vojvodina. Vojvodina provided teachers, administrators, volunteers, and specialists to hasten the modernization and Westernization of the emerging state. Not for nothing the Serbian Church hierarchy established itself in Sremski Karlovci, which we visited in a previous chapter. Teacher's schools, such as the (first) one in Sombor, provided instructors to educate the heretofore-unschooled masses in Serbia. Stavrianos quotes a popular Serbian ditty, "Montenegro with its doughty warriors saved the Serbians from despair; the Vojvodina with its schools and presses saved them from ignorance."[35]

The other key to the emergence of a proud Serbian state was its illustrious pre-Turkish history. For this reason, I had to go to Smederevo. The reason I had to go is not only because Smederevo was a key Serbian Medieval site, and by no means was it the most important. Many of these sites are now in Kosovo and Montenegro, and I had no desire to go to Kosovo. Rather, Smederevo represented to me modern Serbia, a complicated mix of Danubian and Byzantine. Medieval and modern here coexist, in a complicated harmony, with that intimacy Europeans seem to possess for monuments of their past history.

Arriving in Smederevo, I had a sense of déjà vu, for in utter contrast to an almost Germanic Vojvodina, I felt like I was arriving in a more verdant Greek village. A cemetery with an Orthodox Church on the outskirts, a winding hilly road with no sidewalks, Smederevo reminded me of countless

[34] Stavrianos, 251.
[35] Ibid, 235.

Greek towns I have motored through on my travels. Though Smederevo has one of the largest fortresses ever built in Europe, a continent teeming with fortresses, the signs to the site were few and far between. The Serbian North-South Autobahn had no telltale brown historical interest sign, and in driving through the town, we used signs to the center and dead reckoning to find the fortress. The town had that jaunty haphazardness of typical of the Balkans. I felt at home.

Historical sites in Serbia lack the hype of such places in other countries. There is none of the Anglo-American penchant for over-emphasis, over-intellectualization, and (particularly in the American case), over-commercialization. Here in Serbia this huge fortress, one of the most important in European history and absolutely central to Serbian history, lies on the far side of the town railway station, with no real partition between the station and the beginning of the fortress. The fortress' entrance is a gaping hole in the walls, a complete ruin, victim to the Germans' World War II bombing of the railyards; munitions cars exploded and destroyed a portion of the fortress, much of the surrounding town, and killed well over three thousand people.

We pulled up our car to the "parking," really a gravel/grass patch next to the fortress, as there is no designated parking. Our guide, a bright local fellow, was waiting for us. Entering through the "hole," we were in Medieval Serbian Smederevo, now bereft of buildings and grassed over, with playgrounds, park benches, and seasonal kiosks where a teeming late Byzantine city used to be. The only structures partially remaining were those of a Turkish bath, recalling a sojourn that lasted four hundred years on this site.

The massive walls are familiar to anyone having witnessed Byzantine fortifications elsewhere. My son, somewhat bored by the seriousness of a guided tour, commented that "this place is just like Salonika," and indeed Smederevo's fortifications readily remind of Salonika, or those of Constantinople, which Smederevo sought to be, in miniature. In this sense, Smederevo is a mirror in architecture for the Medieval Serbian state, a successor and copy of Byzantium. The chief builder was the Despot's brother in law, a Byzantine from the Imperial Kantakouzinos family. The Serbs called Constantinople Tsarigrad, and Serbian King Stefan Dusan proclaimed himself "Tsar of the Serbs and Romans [Byzantines]," and only his untimely death in 1355 precluded his marching on Tsarigrad. Not for the first time I wondered if Dusan had succeeded in conquering

Constantinople, he could have fully reunited the Orthodox Balkans against the Turkish threat. It was not to be.

Serbia at the time was one of the great powers of Europe, among the richest and most advanced states of the time. Serbia's powers were ephemeral, and within forty years the Turks dealt both Bulgaria and Serbia deathblows, in 1371 at the Battle of the Maritsa and in 1389 at the Battle of Kosovo respectively, and both retreated to vassalage or outright servitude. Bulgaria would not rise again for five hundred years. Serbian power was not fully spent, and most particularly the Serbians participated in the general Late Byzantine Era intellectual and cultural Indian Summer before the final collapse. With the Serbian heartland under Ottoman rule, Danubian Serbia became the rallying point for the Serbs' final stand against the Ottomans. In this, the Hungarians on the other side of the Danube (and ensconced in Belgrade) were active allies as they too, worried with good reason about the Turkish onslaught.

With their backs to the Danube, and with a Hungarian alliance, the Serbs began building Smederevo in 1429. This was not the first structure here, the Romans also had a frontier outpost called Mons Aureus nearby, and from the riches in the Smederevo museum, where we had the place literally almost to ourselves, the quantity and quality of the Roman antiquities indicated a considerable and important settlement. Built at the confluence of the mighty Danube with a lesser tributary, the River Jezava, the fort absorbed the meager finances of the Serbian Despotate, and the Despot Djuradj Brankovic press-ganged one male member from every Serbian family to assist in the construction. The fort and its inner castle saw action soon and often enough, as the Turks attacked several times. Their final assault, under Mehmed II, Conqueror of Constantinople, in 1459, snuffed out Serbian independence for four hundred years.

Certainly the massive fortifications, in particular the thick castle walls, impressed me as a historical enthusiast, but the romance and the drama of this valiant, kindred Byzantine nation's last stand did not really resonate in these stones as it did, for example, in Mystra's or Salonika's castle. Perhaps it was the state of the site, which both the guide and the ticket taker lamented. I could sense their embarrassment. When my wife mentioned that she had visited twenty years before, the caretaker sighed, "Well, then you've seen it. Nothing has changed."

We then walked out of the castle and the surrounding fortress, across the railway tracks towards the modern city of Smederevo, and I thought of

the American expression "on the wrong side of the tracks." Seems like all of us ex-Byzantines ended up on "the wrong side of the tracks."

Crossing the tracks, I was reminded about how wrong it was to feel that way, at least in part. Past a monument to the lives lost during the German bombardment of the train station and, by extension, the fortress, the guide turned our attention to the Smederevo Museum, a few blocks from the station and toward the town center. The museum attendant was not in her booth, but the guide called out to her and she came to cut us tickets. Aside from us there were one or two visitors; otherwise, we had the place completely to ourselves.

The museum chronicled the history of the region over two thousand years, with proto-Slavic dugout canoes, known to the Byzantines as *monoxyla* (literally in Greek "from one log"), which plied the rivers of the Balkans and even made attempts on the Greek islands during the first Slavic incursions into Greece, exquisite Roman pottery and corroded remnants of military equipment, as well as artifacts, replicas, and documents from this last era of Serbo-Byzantine existence, before the fall. Here was a highly literate and intellectually confident civilization, and the crafts from the Turkish and post Turkish period looked, if anything, older and more primitive than the Roman or Serbo-Byzantine artifacts. It eloquently and poignantly reminded me that what was plowed under by the Turks was the most intellectually advanced civilization at the time in Europe. The frescoes depicted here, and those in other Byzantine sites, showed heady movement toward the Renaissance, which these Byzantine states fostered, but would not survive to participate in fully.

It was probably just as well that we had the kids with us, because if I had really been able to focus, I probably would have become more depressed that so few people, even in Serbia, knew the significance of the site we had just visited. While lacking the drama or the physical, topographical beauty of Mystra or Constantinople, here is yet another place where Byzantium, the millennium-long high civilization of Europe, expired. In the West, where historiography often passes over this huge empire and impact with a wave of the proverbial hand, Smederevo is unknown. Here in Serbia, a combination of economics, disorganization, and perhaps the problem of too much, rather than too little, history, leaves the site as a neglected backwater.

After the museum, we walked into town, to see the Church of St. George, an imposing structure built between 1850-1854, just as the autonomous Serbian Principality was wresting Smederevo from the Turks.

Its domed cupolas readily express its Byzantine heritage, but the height and layout of the structure, together with the exterior moldings, indicate that the architects incorporated styles prevalent across the Danube, in what was Austro-Hungarian Vojvodina. The frescoes in the interior also represented a fusion of styles, which again fit the nature of the new state then emerging from the Ottoman yoke. Across the Danube frontier, hundreds of thousands of Serbs lived in Vojvodina, and aided their brethren in formerly Turkish-controlled Serbia materially, but also intellectually and culturally. At its best, Serbia is a fusion of both sides of the Danube, the Balkan-Byzantine legacy and the more progressive Central European influences of Austria-Hungary. This church represented, in architectural form, modern Serbia, a Danubian state. Serbia's challenge, then as now, is to make this fusion a success, so far quite elusive.

After coffee along a predictably café-filled pedestrian zone, we said goodbye to our guide, and made our way back to the car, over the tracks, and then on our way. Ten minutes away was the bridge that would take us across the Danube, back to Vojvodina, still in Serbia, but somehow like another country altogether. My wife, a mixed Vojvodina Serb, smiled and said, somewhat tongue in cheek, "we are back in Europe." The first village in Vojvodina, Kovin, with its wide streets, sidewalks and elegantly crumbling baroque facades, seemed to agree with her.

Chapter XIII

"To the City" of the Tsars

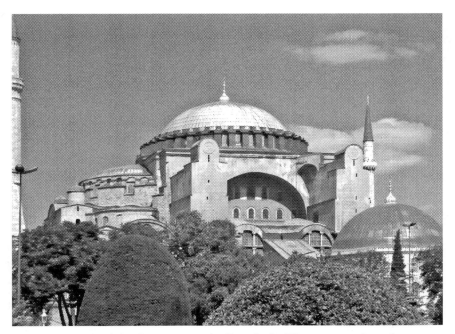

Agia Sophia, Constantinople (Istanbul). The massive domed edifice built by Byzantine Emperor Justinian and the crowd symbol of all Byzantine peoples. Photo by George Dratelis.

Names and what they connote possess a great deal of meaning. Just think of the various terms used to describe Istanbul: Constantinople, Tsarigrad, The City. Konstantinoupolis, the City of Constantine, the Emperor who institutionalized Christianity in the Roman Empire, connotes a totality of belief and thought, a vastness of faith and polity. "The City," *I Polis*, to a Greek requires no further explanation, there can only be one such city. Even the Turkish Istanbul derives from the Greek prepositional phrase *Is tin Polin*—"To the City," which shows at once the true origins of the city and its universal attraction. My favorite is the term used by Orthodox Slavs, *Tsarigrad*. The City of the Tsars, where the Tsar should sit, and the Tsar who reigns from that city, by definition, reigns over all of his people. *Tsarigrad* connotes totality and universality.

Since Constantine founded his New Rome, Constantinople, on the shores of the Bosporus seventeen centuries ago, the city has dominated the Asia Minor and Balkan Peninsulas, along with the Aegean and Black Sea basins. Not until the Turks' crushing defeat by the Balkan League of Greece, Serbia, Bulgaria, and Montenegro in 1912, did this dominance of Constantinople end. Istanbul's eclipse was seemingly furthered when modern Turkey's founder, Kemal Ataturk, moved the capital to the inland city of Ankara, well out of the Greeks'—and others'—reach and influence. The Turks, however, did manage to keep a foothold in Thrace, including Istanbul, which declined in the mid-twentieth century, cut off from its Balkan hinterland by the barbed wire of borders hermetically sealed, and new ideologies, such as Communism in Bulgaria and Romania.

Despite Constantinople's many years of dormancy, the country controlling the city has the potential ability to dominate both the Asia Minor and the Balkan peninsulas. By evicting the Greek army from Smyrna and expelling the Byzantine Greek populations of Asia Minor in 1922, the Turks consolidated their control over Anatolia, a mini-continent the size of Texas. There, the Turks reconstituted a very powerful state. Unlike the recession doldrums and sovereign crises in Europe, the economy in Turkey is booming, with double digit growth. Turkish manufacturers are capturing much of the low cost consumer goods trade increasingly in Europe; Turkey is becoming a mini China. In Istanbul, by the 1960s, the city began to emerge economically, even though at the time, it grew in a haphazard, Third World manner. Now, Istanbul is the center of this astronomical growth.

The Eagle has Two Faces

In October 2007 I finally went to Istanbul with my wife, after three decades of wanting to, thinking about it, and false starts. The City was simply too vast and emotional for a Greek to travel to lightly. For my wife, a Serb, the weight was similar although somewhat diffused by the further distance between Serbia and Istanbul. As we were to discover, the distance was not as great as we thought.

I left from Athens, where we lived and worked, and my wife left from Belgrade, and we both arrived in Istanbul the same day, in a pincer movement designed to "take back the city," I joked to Athenian friends. The flight from Athens (or Belgrade) to Istanbul takes less than an hour, and I arrived on a very overcast morning into Ataturk Airport, gliding downward through the mists of the Sea of Marmara. I arrived at seven o'clock in the morning, to a city yet to stir fully, and my cab traced its way around the old city walls, scenes of so much history, victory, tragedy, and drama, now in various places restored, in other areas crumbling, and in yet others the walls themselves form part of the structure of homes wealthy and modest.

Few cities are so blessed by geography and topography as Constantinople, but the price for such favor is costly. First, everyone coveted the city, so it suffered innumerable sieges, massacres, and famines, second, below the city's surface some of the world's deadliest fault lines lurk, shaking the city periodically, and tens of thousands die. But the scene, even in autumn morning drizzle, cannot help but impress. The old city juts out like a hitchhiker's thumb, into the Sea of Marmara, which narrows to become the famous Bosphorus, more like a river gorge than a waterway. Another small waterway, the Golden Horn, city's old, horn-shaped port, separates the "thumb" of Constantinople from the posh Galata and Beyoglou Districts, where we would stay.

Rounding the tip of the "thumb," we skirted the Golden Horn, and to my left, I saw it. St. Sofia, a squared, rust-orange colored edifice which seen from afar was slightly less impressive than I thought. As we prepared to cross the Galata Bridge, another mosque appeared which, minus minarets, would pass for a double of St. Sava's Cathedral in Belgrade, clearly showing that the origins of much of Ottoman architecture are Byzantine.

Upon arriving at the Hotel and registering for my Trade and Credit Conference (the business purpose behind my trip), I hailed a cab to take me to the old city before going to fetch my wife from the airport. The old city is such a dense zone of history, so much that it is impossible to appreciate without a protracted stay. The only other alternative is a

cursory glance favored by the packaged tours, a gross injustice to the depth of the place. I walked by the vast St. Sofia, again simply intimidated by the profundity of the church/mosque itself and far more by what it represents. It lacked the classical grace of the Parthenon, that other symbol of Hellenism, but in terms of sheer envelopment and density, it is peerless. Walking around the streets of this area, there are constant juxtaposes of the Byzantine and Islamic, incompletely fused, but to a Greek intimately familiar even if one had never visited the place before. The scene vaguely reminded me of the *Plaka* district in Athens, with some of the same type of houses, the *mahala*[36] style disorganization of the streets. As in the *Plaka*, ancient, Byzantine, and Ottoman edifices competed for space and attention, though the scale in Athens was smaller, infinitely less regal, and there the classical monuments, crowned by the Parthenon high on the Acropolis, predominated.

Arriving to pick up my wife at the airport, we returned via train, as the Istanbul rush-hour traffic made a cab trip an expensive and long ordeal. The train cut through the suburbs of the city, bisected the land walls of Constantinople, we rolled through suburbs with names recalling the Turks' own refugee experience, such as *Yeni Bosna* (New Bosnia), just as the Asia Minor districts of Athens, such as *Nea Smyrni* and *Nea Ionia*, recall lost homelands of these Greeks. Turkey, like the other Balkan states, had its own refugees and dislocations as a result of Balkan conflicts. On the train we sat next to an older Turkish man with a blond mustache and his teenage son, who in halting English welcomed us to Turkey, and told us that we, as Balkan people, were "brethren." His father, who could not speak English, welcomed us by shaking hands very formally and told us through his son that he was "honored to meet us." To make sure we found our way, his son led us to our connecting bus, and paid our fare! Reaching the hotel, we planned our journey.

I preferred to let history and topography to be our guide, and also I knew that a short trip simply could not even scratch the surface of this eternal city. A whole season might begin to do it justice, but for the impressionist sketch, we did our best. I also did not want the tour to be a mourning of the siege and the last stand of our last Emperor, the Serbo-Greek

[36] *Mahala* is a Turkish term for district or neighborhood that has entered into the lexicon of every Balkan language. It usually refers to a poorer, shabbier part of town, lacking city planning or modern buildings and conveniences.

Constantine Paleologos, who died resisting the Turkish conquest in 1453. Also, at this stage, I did not want to visit the Orthodox Patriarchate, as this living institution has been so abused by the Turkish authorities that I feared it would too much color the whole trip. We had to paint our impression quickly, on the damp plaster, like the fresco artist. What I did see, even in a short trip, greatly altered my view of the Balkans' future.

The next morning a melancholy rain obscured the view of Asia from our fourteenth floor window, and after a hearty breakfast, I asked the concierge to hire us a cab to take us over the northern bridge to Asia, drive along the Asian shore of the Bosphorus to *Anadolu Hisar*, and then over the southern bridge back to Europe, and then into the city to attempt to do a real justice to monuments in the center. We drove north along the European side of the Bosphorus, past Ottoman palaces and exquisite mosques, and looped into the city to reach the northern bridge. There, in the foothills crammed with five-story flats, we began to appreciate the sheer vastness of the city; a sea of unsteady concrete perched uneasily across seismically challenged foothills. The City was the largest in Europe for hundreds of years, and today it is again, with well over 16 million people, four times the size of Athens, and double the size of London or Chicago, all cities we have lived in. This, more than the amazing monuments, was what my wife took away from Istanbul, that it is a sea of humanity spreading over Europe and Asia. The power of this metropolis, the center of gravity of the Balkan and Asia Minor peninsulas, spread before our eyes.

We jumped on the Autobahn, crossing the *Fatih* (Conqueror) Bridge over the Bosphorus, a placard welcomed us to Asia, both of us adding (at least in a technical sense) another continent to our travel list. The driver veered right on the first off-ramp, and set a course down the hills to the Asian side of the Bosphorus. There we drove past the nouveau riche villas, ex-Greek fishing villages, and delicate, decaying Ottoman *Yalis* (coastal wooden villas) to *Anadolu Hisar*, a small castle that was the first step in the eventual Conquest of Constantinople. Built in the late 1300s, as the Turks absorbed the Asian side of the Bosphorus, the castle regularly enforced the blockade of the city.

The "Castle of Anatolia" sat in a lovely setting belying its sinister task, but the sniffly weather only allowed for a few photos. This mournful sheet, a collision between the steppe climate of the Black Sea and that of the balmier Mediterranean, created a drizzling melancholy, described in

depth by Orhan Pamuk, the Pulitzer Prize winning Istanbul novelist, as *huzun*. Pamuk describes *huzun* as a type of melancholy associated with a sense of loss[37], and the historical weight of the city, its lost glories, and missing inhabitants, combined with this climatic tendency for mist and drizzle, certainly fosters this weighty feeling.

Moving on, we passed through more shock-urbanized villages and assorted villas that obviously had wealthy owners, till we reached the Ataturk Bridge, and returned to Europe, the continent where the Turks want to pin their identity and their future. The other Bosphoran castle, *Rumeli Hisar* (the Castle of Europe), we would meet in a few days.

The driver took us across the *Galata* Bridge into the old City of Constantinople, and we had a vague feeling of similarity to crossing the Sava River into Belgrade. Minus minarets, there is something similar between Istanbul and the hilly Serbian capital crowned by its own "St. Sophian" Cathedral, St. Sava. Of course, both descend from a common culture.

Our destination was obvious, St. Sophia. We decided to forego a guided tour and just walk our way though by ourselves. I had heard so many different accounts from Orthodox—Greeks, Serbs, or Russians—that it somehow felt so wrong, so hurtful. I even knew of someone who was escorted out for starting an Orthodox liturgical chant. For us, there was a feeling of vastness and also the spatial emptiness that came, most likely, from its former and more recent role as a mosque. The geometric artwork also came as a bit jarring to one who had always associated St. Sophia with a church, but made more sense once we visited the Blue Mosque, a few hundred meters away. Again, the structure that St. Sophia most recalls is St. Sava in Belgrade, which I visited while still in construction, when the Serbian cathedral had a bare interior. In both places one sensed the circular, spatial, embracing totality of God, though without the earthly accoutrements of Orthodox religion in the form of Iconostasis, and icons.

The most moving part of St. Sophia lies in the upper galleries, where careful work has brought some of the greatest mosaic icons in the world back to life, and "living" truly describes some of these icons, including one of Jesus that looks as if He is drawing breath and ready to speak. We sat transfixed, taking pictures of the Image to which no photo can do justice. This Image of Christ can only be perceived by being there. Other icons too, liberated from centuries of Turkish plaster, traced the history of the

[37] Orhan Pamuk, Istanbul, (New York: Alfred A. Knopf, 2005) 91.

Byzantine Empire, which lasted over 1000 years. In an off-color comment to my wife, I declared, "you see, the truth comes out!"

Making our way out of St. Sophia, we emerged unshaken but rather feeling that the decision of Kemal Ataturk, the founder of modern Turkey, to make St. Sophia a museum indicated far-sightedness. Salonika-born, Attaturk wanted his country to be European, and so much of the roots of his country, such as Constantinople itself, are European and Christian, but his people are Muslim. As a museum, St. Sophia satisfies neither Orthodox nor Muslim, but it reflects the reality of the situation and the necessity for compromise. Further, it reflects a historical accuracy in a region known for the victors on all sides to have a tendency to plow under the history and identity of their predecessors. St. Sophia does the opposite.

Perhaps an aside on Ataturk makes some sense here. The founder of modern Turkey, he is revered by a majority of Turks, secular or religious. He died in 1938, but his visage remains ubiquitous, much as Tito's picture did while he was the Communist ruler of Yugoslavia. Tito's state outlived him by only a decade, but Ataturk's state is thriving. In the former Yugoslavia, though many people still pine for the old federation, Tito's visage is seldom to be seen, but Ataturk is everywhere in Turkey still. When we visited Turkey, my wife and I thought that this was a sign of Turkish state's insecurity; if so much depended on one man's legacy, how secure was this state? Now, seeing the Turkey that is emerging, as a regional economic, military, and cultural heavyweight, I am not so sure.

The next stop on our itinerary was the Blue Mosque, architecturally a clear descendent of its neighbor, St. Sophia, though built 1000 years later. There too, the dome work and higher walls are a credit to the skill and faith of its builders. Having never been to a functioning mosque, I had expected the interior to be somewhat similar to churches but what we witnessed, in stockinged feet, was a vast emptiness and the geometric patterns of an oriental carpet both below our feet and along the walls and domes. Suddenly, the emptiness of St. Sophia made sense, and its austerity reflected an interpretation of God that fit the nomadic origins of the Arabs, and the original Turks, themselves nomads who burst out of Central Asia. There too, we felt a symmetric beauty that demands both respect and study to understand it further. I have heard that Adrianople, known on maps as Edirne, on the Evros River just opposite Greece and Bulgaria, has some of the finest Ottoman architecture in the world, suitably off the beaten path of tourism but very much worth an extended visit.

Always, in my travels, I have preferred the more obscure and significant, to the packaged mass tour, which has the effect of obscuring the significant. Thus, the Blue Mosque and subsequent *Topkapi* Museum did not have the effect they deserved, because the galleries and rooms were filled with tourists milling in a traffic control pattern. What remained from Topkapi were the beautiful kiosks, and the sweeping views of the Golden Horn, which we appreciated with a lunch in *Topkapi's* restaurant. As usual, the Turkish cuisine, familiar to us as Greek and Serb, did not disappoint, and at the neighboring table a woman from Salonika, Greece, told us that her mother was expelled from Istanbul in the 1960s, but returned constantly, to "re-fuel." Her mother had never gotten over leaving "The City." More *huzun*.

The delights of the Covered Bazaar I left to my wife, while I attended my various trade and banking meetings, but in the lunches and coffee conversations, I spoke to many Turks, among them a professor of history, and in most of these conversations I sensed a clear knowledge and a mild guilt about the lack of a Greek presence in the City which was, after all, built by the Greeks' Byzantine ancestors. The city had a very large Greek population until the deportations of the 1950s and 1960s.

There was also much talk about the National Bank of Greece's purchase of Finansbank, one of Turkey's largest, as an "economic reconquest of Turkey." In 2007, "rich" Greece still looked down on "poor" Turkey, and I took a weak comfort in that.

However, as I looked around the conference, at the plethora of businesses represented, I thought about similar conferences in Athens, where foreign presence was small. I thought of the huge corporate headquarters I saw in Istanbul, and the constant construction of new office and factory space, all portents of a rising and vast economic power. Then, once again, looking out from our high-rise hotel room, the vast sea of humanity on two continents, presaged a changing reality for the wider region.

On the evening before we left, the seminar ended with a boat tour of the Bosphorus, sailing between continents, and as we glided past the Ataturk and *Fatih* (Conqueror) Bridges, we saw from tens of meters away the beautiful villas and restored Ottoman *yalis* of a bygone era, and felt a quiet solitude in the midst of a city of millions. To complete the story of the castles, we glided past *Rumeli Hisar*, much larger than its Asian counterpart, which extended on the nearby hill and commanded an excellent field of fire for any passing ship. I use "field of fire" deliberately, as the Mehmet II, the *Fatih* (Conqueror) of Constantinople, built this

castle in the space of a few months in 1452 to seal off Constantinople from any supplies coming from the Black Sea, and cannons set on its battlements sealed the deal, sending ships laden with supplies for the City to a watery grave. The Turks called it *Bogaz Kesen*, "cutter of the channel," and the Greeks called it *laimokopia*, "cutter of the throat."

Sitting on the back deck of the tour boat, well within the sight of *Rumeli Hisar's* cannons, I talked to a Dutch-born Turkish professor. We were both children of the Diaspora, and descended from this common region. He acknowledged the legacy of Byzantium, and the loss of the Greek population as part of that painful separation brought about by nationalism on both sides. In a sense, Istanbul is still the capital of the Balkans, as the Byzantine world endures in the cultures of the Balkan Orthodox, and more than that, in the Ottoman Empire which held us in thrall for a further 500 years governed out of this City, where Byzantium was conquered but never fully dominated.

Three years have passed since our first visit to the Tsar's City, and in 2010 Istanbul reigns as the Cultural Capital of Europe, with a booming economy and full of confidence. Turkey's political, economic, and "soft power" has brought it membership in the G20. Turkey had the power to take on Israel, and its diplomats were all over the Balkans and Middle East, building political and economic bridges in Turkey's "near abroad," places where Turkish imperial rule was often just out of living memory. The thing that brought this home to me was a picture in Politika, Belgrade's premier daily, showing a smiling Turkish prime minister standing next to his Serbian counterpart, opening a "Turkish Cultural Center" in Novi Pazar, a south Serbian town with a restive Muslim minority at odds with the Serbian regime.

The same Turkish prime minister told his crisis-ridden Greek counterpart that Turkey would stand by its Greek neighbor, no doubt to the *shadenfreude* of the Turkish press. I recalled our visit in Istanbul, and the talk of the National Bank of Greece's growth in Turkey. In 2009, this bank's Turkish subsidiary, Finansbank, had the highest profit of any of National Bank of Greece's subsidiaries, prompting pundits to speculate on a reverse buy out of this Greek national champion, which also has a huge network in Bulgaria, Serbia, Romania, and Slav Macedonia. Istanbul's centripetal power is pulling the Balkans back into a neo-Ottoman orbit.

I thought again of the ubiquitous portraits of Ataturk. He saw the Ottoman Empire collapse, and his hometown, Salonika, become part

of another country. He was determined to reconstitute a Turkish state centered in the vastness of Asia Minor, while keeping a European foothold, including Constantinople. Then as now, the Tsar's city is the navel of the region, and the regime that controls this city, as history time and again shows us, has the potential to dominate the Balkans and Asia Minor.

Chapter XIV

Pontus, Sacrificial Lamb of Byzantium

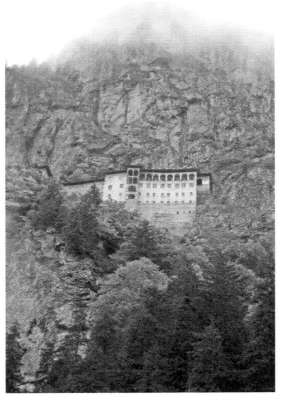

The Monastery of Panagia Soumela, a site sacred to Pontic Greeks, a branch of the Byzantine family now in exile (or converted to Islam if they remained) due to the politics of nationalism. Empty for over eight decades, the first Orthodox service was celebrated in 15 August 2010, to honor the Dormition o the Virgin Mary. Photo by KUSKON via Shutterstock.

Pontus is a pillar of *Romiosini*, of Byzantium, decapitated in the consolidations of the Greek and Turkish states. Pontus' lush green hills dropping steeply to the Black Sea, punctuated by verdant valleys, present a geographical contrast to the Aegean Hellas we today associate with Greece. Greeks settled in Pontus, in depth, several thousand years ago, and formed kingdoms in the Classical and Roman eras. Pontus' most famous period of independence and cultural flowering occurred as the Empire of Trebizond, formed as a shattered fragment of the Byzantium after the perfidious Fourth Crusade temporarily dismembered the Byzantine Empire in 1204.

The Byzantine Empire cobbled itself back together in 1261, but like a shattered piece of fine china, pieces were missing, and the luster never returned. Trebizond, under the famous Komnenos Dynasty, survived as a separate state for another two and a half centuries, with its own emperor, and built a respectable commercial state, with appendages in the Crimea, and commerce throughout the Black Sea. While still acknowledging its holy membership in a larger Byzantium or *Romiosini*, Pontus went it alone, and actually outlasted the Holy City of Constantinople and Mistra, succumbing to the Turks in 1461.

The Pontian experience after the Turkish conquest was similar to the plight of other Byzantine Christians who fell under Turkish rule. The *millet* system was in full force, with its measured freedoms for the Byzantine conquered. The Pontians were less exposed to the *devshirme* roundups for the Janissary corps than the Balkan Christians, but nonetheless there was a steady stream of conversions to Islam, voluntary or otherwise, right up to the date of the expulsions in 1923. Notwithstanding the defections to Islam, like other Byzantines, they remained nonetheless cohesive with an identity rooted in *Romiosini* and their local Pontic "patrida." A national, Hellenic consciousness did not yet exist. Again, it is remarkable the degree to which the members of the *Rum milleti* combined a broad civilizational identity (Byzantine) with geographical, semi-ethnic, linguistic identities (Pontic, Serbian, Wallachian). The connections between these sub-ethnicities were generally fluid, so mixtures were common and quickly assimilated, but geographic, cultural, ethnic, and most importantly, religious, barriers remained.

The Pontic "Camelot"

The Greek War of Independence did not particularly galvanize the Pontic Greeks. Geography certainly played a role; Pontus was far away

from the center of revolution, and hideously exposed to Turkish revenge. Further, Pontus was a center of Byzantine culture in its own right, and, like many Asia Minor Greeks, the Pontians considered the inhabitants of Aegean Greece to be uncouth, "semi-Albanian" ruffians. Certainly the greatest Byzantine cultural centers, cities such as Salonika, Smyrna, Ioannina, Constantinople, and Pontus' own Trebizond, were outside what became the original Kingdom of Greece. Pontus' "capital" Trebizond, had strong cultural historical credentials as the last Byzantine outpost, and Pontians had a highly developed—and distinctive—language, culture, and customs.

Nonetheless, the Pontians did respond to several effects of the Greek War of Independence. In hindsight, it was as if a time bomb had been placed under their world, with a slow-burning fuse. Many clearly saw the signs. Pontic Greeks had been immigrating in substantial numbers to the north coast of the Black Sea, to the Russian Empire, where they became loyal servants of an Orthodox sovereign. In many cases, they were bolstering settlements that had been Greek-speaking from Classical antiquity. The Russian Army invaded Eastern Turkey and the Pontic region in 1829 as part of their attack on the Ottoman Empire in support of the Greek rebels. As the Russians descended on Pontus, many of the Pontians welcomed them as liberators. Many Greeks, especially during the Revolutionary Era, had a messianic belief in Russian liberation. As such, many Pontians actively supported the Russians, and left with the Russian army after its withdrawal in 1830. Many assimilated into the Russian Orthodox population; others remained a distinct ethnicity in the Russian Empire. As we have seen, still others would return to their titular homeland, Aegean Greece, almost two hundred years later.

At the same time as the Greek revolution, the whole Ottoman Empire began to be integrated into the world economy. Pontians, like other Orthodox minorities, actively participated as merchants and middlemen. The establishment of Russian control over the northern littoral of the Black Sea coincided with the active growth of the Greek merchant fleet. The Greek fleets typically centered on individual Aegean and Ionian islands, notably Hydra, Spetses, Cephallonia, Andros, and Chios. The Greek fleets dominated the Black Sea and lower Danubian trade, and linked the Pontians with a Byzantine world that was increasingly "nationalized" as Hellenic, an identity narrower than the Byzantine but sufficient to co-opt the Pontians.

The new Greek state, though in utter poverty and chaos, poured its meager resources into the liberal arts faculties of the University of Athens. Greece turned out thousands of educators, well beyond the petty kingdom's absorption capacity. As a result, many of these teachers left to teach the far-flung Byzantine communities in Asia Minor and Macedonia about their ancient history and their organic link to a Hellenic motherland with Classical Greek roots, sprouting from Athens. Pontians and their Athens-educated teachers grafted Pontic history onto a common Byzantine tree and began to agitate for freedom, and, possibly, for union with a country hundreds of kilometers away. Pontic Greek remained spoken, but the educated dandies of the towns now affected a *Katharevousa* [38] dialect of the Athenian newspapers and literati as a sign of their education and Hellenic consciousness.

Pontians, like most Byzantines—or by the 1880s—"Greeks," remained attached to their geographic homelands and to their distinctive traditions, but the global economy and Hellenic nationalism had its effect. Moreover, the "*millet* mentality" of identifying religion with nationality meant that Pontic identification with Greece was restricted to Christians alone, and not to the numerous Pontic Muslim converts. Like elsewhere in the Balkans, the *millet* reigned, and national identities would not and did not cross the religious fault lines. These lines remain essentially to the present day.

The turn of the twentieth century, the classic *fin de siecle*, was a period I like to characterize as "empire nostalgia." Three great houses on the map of Eastern Europe—the Hapsburg, the Romanov, and the Ottoman—were to enjoy their last days as part of their respective multi-national, imperial experiments. None of the three houses were democratic, all were regressive, and all, to some degree, were using state terrorism to keep their minorities in check. Nonetheless, in all three cases, but particularly in the Hapsburg and the Ottoman realms, there was a flowering of the nationalities and the expansion of economic growth.

The Ottoman Empire was an institution of both incredible tolerance and chaotic barbarism, in which the Greeks and others existed on the edge

[38] Katharevousa is a nineteenth century codification of the Greek language seeking to preserve as much as possible the Ancient Greek form of the language, removing foreign words and influences. For generations in Greece, official documents and a fair amount of literature were in Katharevousa; only the mid 1970s did demotic Greek become the official language of Greece.

of a precipice. Thus, at one end of the Ottoman Empire there could be massacres of the Armenians and in other areas, Ottoman Greeks would openly collect funds for the Greek Army. In the short war between Greece and Turkey in 1897, many Greeks from the Ottoman Empire duly joined the Greek Army, and then returned to Turkey after Greece's defeat with no apparent consequences for their legal status or personal safety. The Pontians shared in this general condition, growing in prosperity vis-à-vis their Muslim neighbors and increasingly hitching their cart of destiny to the Greek horse.

The Earthquake

Pontians watched the victories of the Balkan League in the Balkan Wars of 1912-1913 with joy, but certainly with an increasing apprehension. The Ottoman Empire was losing more and more territory, and the local Muslims' anger was rising. These Muslims received further incitement from refugee Turks and other Muslims fleeing lost provinces in the Balkans and the Caucasus. These former landlords were suddenly impoverished refugees living cheek and jowl with often increasingly prosperous Christian communities, whose co-religionists had evicted them from places like Bulgaria or Abkhazia. The Muslims increasingly began to resent the local Christians, and to act on these resentments.

While the local bases for hostility and eviction were forming, the Turkish state itself was undergoing a change in leadership and culture. Just as their Orthodox subjects, the Turkish Muslims were grafting the Turkish language onto the Muslim *millet* to develop a Turkish nation-state wherein Islam was a constituent element and *sine qua non* to the membership in the Turkish nationality. In this new Turkey there would be room for only one religion, Islam. Further, with nearly all of the Balkans in Christian hands, the Turks were determined to keep Asia Minor, that mini-continent, intact as the Turkish homeland, for Muslim Turks only.

In 1912, the Balkan League alliance of Greece, Bulgaria, Serbia, and Montenegro shattered the Turkish forces, and Bulgarian armies stood at the gates of Constantinople. Even though the Turks were able to regain Constantinople's Thracian hinterland, the very hearth of the Turkish nation was in peril of dismemberment by their former subjects who would not tolerate any Muslim self-determination. Turks flowed out of the Balkan territories, and the Greek communities of Asia Minor and Thrace, having

tried to realize the best of both worlds, realized that this brief opportunity was coming to an end. Many Greeks began immigrating to Greece, sensing that it was better to leave before evictions began. Hundreds of thousands left from Eastern Thrace and western Asia Minor, but those further inland often lacked the means or connections to make the move.

No sooner did the guns silence from the Balkan Wars, they began again. World War I broke out and Turkey joined the Central Powers in 1915. Greece remained neutral but the Turks felt that the Greeks and Armenians of Asia Minor would support Russia, an Allied country. The Turks threw down the hammer of genocide against both peoples, most specifically and absolutely the Armenians. Time had run out. The Ottomans had lost the Balkans, and were determined not to lose Asia Minor.

Greece joined the Allies, and the British smashed the Turkish forces in the Middle East. Turkey sued for peace and faced occupation by the Allies, including Greek forces in Eastern Thrace, within sight of Constantinople, and an occupation zone in the heavily Greek Smyrna District, in Asia Minor. By 1919, suddenly a "Greece of the Two Continents and the Five Seas"[39] became a distinct possibility.

Pontus, located on the Eastern Black Sea coast of Asia Minor, was far away, even from this ephemeral "Greater Greece" and utterly vulnerable. Even the most starry-eyed Greek expansionists knew perfectly well that expansion to Pontus was out of the question. Many in the Greek Army General Staff, including the future dictator General Ioannis Metaxas, already felt that the Greek Army was dangerously overstretched. Pontics had either to seek some sort of independent state, perhaps a federation with Armenia or Georgia, or flee. Russia no longer acted as a protector as in years past. In fact, Lenin's Bolsheviks emerged victorious in the Russian Civil War of 1918-21 and actively assisted the Turks in throwing out the Allies. The Greeks actually sent forces to the Ukraine to help the French fight the Communists, and, in a gesture at once symbolic and of complete futility, bestowed Greek passports on the inhabitants of the Greek communities in Russia and Ukraine, something that did not endear the local Greeks to the Bolsheviks and would haunt these people in the future, though these faded documents would be produced seventy years later by

[39] In the period 1919-1923 Greece had territory in Asia, the Smyrna enclave, as well as European Greece. Further, Greece's shores touched the Black Sea and the Sea of Marmara, which, added to the Aegean, the Ionian, and the Mediterranean, was a Greece of the Five Seas, along with the "Two Continents."

their *Rosso-Pontioi* (Russian Pontian) descendents to seek immigration to Greece, and Greek nationality.

On the south shore of the Black Sea, in the remnants of the Ottoman Empire, the Turks had a leader who compared favorably with Greece's Venizelos, and far more ruthless, Mustafa Kemal, later known as "Attaturk"—father of the Turks. Kemal knew exactly what he wanted, a Turkish nation-state on the European model but built on the Turkish language and the Muslim religion. In this sense, he learned from the former subjects of the Ottoman Empire who carved Orthodox nation-states out of the Turkish Empire in the Balkans. Born in Salonika, he knew first hand that nation building often results in evictions, and he did not shirk from any means to build a Turkish state within the geographical boundaries of Asia Minor and Eastern Thrace.

At the same time, the Greek forces were not content with Eastern Thrace and a modest holding around Smyrna, and advanced forward along a broad front, with the goal of extending Greek control into the harsh interior of Asia Minor, where few Greeks lived. The Turks suffered defeats but fought in retreat, luring the Greeks further into the country, extending their supply lines, and harassing them constantly. Think of Napoleon's, or Hitler's, march into the vastness of Russia for comparison. Kemal Attaturk mustered his forces at the Sagarya River, outside of Ankara, and fought the Greeks to a standstill, forcing them to retreat. The Turks then smashed the demoralized Greeks' defensive lines, and forced the Greek army to a headlong retreat through western Asia Minor, during which the terrified army committed atrocities that would soon be viciously avenged. The Turks captured and burnt Smyrna, and the Greeks and Armenians who survived the horror of the massacre and fire arrived in Greece, diseased and destitute, and often as not without their male head of household.

As with the Smyrna Greeks, the Pontic Greeks had to go too. In past emigrations from their homeland, they usually left for Russia's littoral, still on their native sea, but the Soviet Union would no longer take in Greeks. The only option left was Greece itself, a land totally alien to them. They hurried down the quays to waiting ships, with few possessions, often missing relatives to hostile Turks, and in cramped conditions of squalor and disease, sailed to Greece. Greece over the course of fifteen years took in about 1.5 million refugees, swelling its population by over 25 percent, mostly from Turkey but also from Bulgaria and Russia. The Pontic Greeks

numbered at least 500,000, having lost a fair percentage of their population to Turkish genocide.

Greece did its level best to absorb the refugees after the disaster of ten years of war and economic collapse, and all parts of the country took in refugees, but Macedonia, Thrace, and parts of Athens received the lion's share. There were solid reasons for this. Southern and Island Greece suffered from overpopulation but Macedonia and Thrace, newly joined to Greece, had more available land for settlers. Greece evicted 400,000 Turks and other Muslims from the province of Macedonia, certain Aegean islands, and Crete, as part of the population exchange with Turkey. Further, Macedonia and Thrace were border areas with large Orthodox Slav populations affiliated with Bulgaria; settling Pontians there boosted the Hellenic element and assisted in the assimilation of the Orthodox Slavs. Using the sam logic, in the 1990s, the Serbian government would resettle thousands of Serbian refugees in ethnically mixed Vojvodina to bolster the Serb presence there.

Pontians became Greeks, and quite vociferous ones at that. Having been expelled from their ancestral lands, they clung fiercely to their Macedonian homesteads and turned back Bulgarian encroachments. At the same time, many responded favorably to the Communist ideology, perhaps due to the platitudes of a more just society after the plethora of injustices they suffered, or due to some lingering association with a Russia which had so often been their protector. In any case, events of the Greek Civil War and its aftermath forced many Pontians on the move again, whether to an involuntary exile in various Communist countries in the late 1940s, or to work as *gastarbeiter* in Germany, Netherlands, Canada, or Australia in the 1960s onward.

The meaning of Imiteros, "One of Us"

Ironically, circumstances in Germany in many ways bolstered the Pontian identity more than the overarching, Athens-centric Greek state. Working in Germany, the Pontic Greeks sometimes found Turkish colleagues from the Black Sea who spoke the same Pontic Greek dialect, and stories could be swapped, common music played, in a mother tongue alien both to the host country, Germany, but also to the "mother country," whether Greece or Turkey. Freed from the strictures of home country, in a foreign and often hostile country, a primal identity could flourish across

religious and national lines. In the cafes of the Diaspora, a mutual longing for a lost country could easily transpose to a lost common identity, before the hardening of frontiers and the division of peoples due to religious conversions, imperial dissolutions, and national violence. In short, for a lost Byzantium which both the Greek and Turkish branches of the common Pontus family shared, but expressed together only away from the watchful eyes of their national governments.

Pontic Greeks did make trips back to their lost homeland, but seeking out lost homes or relatives left behind had to be done discreetly. This was particularly true until recently, as Greece and Turkey faced off in what could only be termed a "cold war." Private experiences abound and are treasured, but generally are kept private to protect the Pontic Turks from undue attention from the Turkish *Devlet Baba*, "Father State." One Turkish economist, Omer Asan, who wrote <u>The Culture of Pontus</u>, faced the wrath of Turkish justice for revealing a large Pontic speaking Muslim ethno-linguistic group in Pontus. These Pontic Muslims do not identify with Greece[40] and as ever, the Orthodox-Muslim divide in the Balkans determines identity. However, the possibility of a cultural and familial symbiosis across the national and religious divides of Greece and Turkey makes both states uncomfortable.

Megalo Peuko Army Base, 2006

Arriving for basic training at Megalo Peuko Army Base, I found myself in a barracks with recruits from all over Greece, and scattered among the lot, from the more hardscrabble districts of Athens, Salonika, or various Macedonian towns, were several dozen Russian or Ukrainian-born Pontic

[40] Here it might make sense to comment on "Crypto-Christianity" in Turkey. I have heard, always second hand, numerous anecdotes about small Crypto-Christian communities in Turkey in Pontus, or in Cappadocia, another key area of former Orthodox settlement. I would not be surprised that, in a nation of over 75 million people, many with have recent Christian forbears, that there is a scattering of secret Christians. Most witnesses are deliberately vague about their encounters with Crypto-Christians, in order to protect them from potential problems in Turkey. I accept and respect that the vast majority of Turks (including those with clear Orthodox antecedents) are Muslims, but I would not be surprised if there are many who still keep a secret Christian (or hybrid) religious identity. It was very common in the past.

Greeks. Their ancestors, in many cases several hundred years ago, fled across the Black Sea into the Russian Empire, and they were to various degrees Russified, some with heavily Russian features, and Slavic-accented Greek. Their connection to Greece was tenuous, based on a Byzantine heritage grafted onto a modern state identity, and their sense of apartness from other Greeks was open and clear. I reached out to them in a common Diaspora spirit, which most of them found incredulous, and other Greeks admonished me to have little to do with them, as they were not "like us."

Pontic survival as a distinct branch of the Greek and Byzantine family faces an uphill battle in a Greece which prefers uniformity even as she herself fades into globalization. The colorful dances and festivals celebrated in suburbs of Athens or Salonika with large Pontic communities, or in villages resettled by Pontian refugees, go a long way to keeping outward trappings of distinctiveness alive. Given the stubborn persistence of this community in various exiles, this cultural branch should remain strong. Even the Pontian dialect survives in music, as one Russian-born army comrade clearly showed me by belting out a Pontic dirge one evening, and gifting me a CD of his Pontian Folk Band. A Serbian monk we befriended in Chicago I met several years later in a café in Athens, only to discover that, after graduate theological studies in Salonika, he served a Pontic flock in a village outside the city, and, out of respect and solidarity, he was learning Pontic Greek from his parishioners.

The inflow of Pontians from the ex-Soviet Union has an important and somewhat distorting effect on the Pontian identity. The generations in Russia have had their effect, but they maintained their distinctive identity in among their fellow Orthodox Russians or in the harsh Turkic fastness of Central Asia, all in a conformist Communist environment. They are in Greece because they are Pontians, and because Pontians, provided that they are either nominally or ancestrally Orthodox, are a Byzantine remnant grafted onto the modern Greek identity. They represent the triumph of culture over geography, and like their fellow Pontians who arrived in Greece in the 1920s, they sacrificed their native geography for membership in the Byzantine-derived Greek nation. They then contributed their passions, their talents, and their efforts for the consolidation of the Greek state within its current borders.

Judging from their songs, their passion, and their tentative intimate contacts with their geographic home, their sacrifice may have been worth it, but still pains them.

Appendix
Brief Historical Perspective

The Byzantine Commonwealth

The first thing to remember about the Byzantines is that they never called themselves by that name. They, and their descendents until the present day, proudly called themselves Romans. At the turn of the last millennium Byzantium's culture, literacy, economic and military powers were unmatched in the European-Mediterranean basin. On the death of Basil II, perhaps Byzantium's greatest emperor, in 1025, its sway extended from Venice to the gates of Lebanon, from the south of Italy to the Crimea and the Caucasus. The Slav peoples of the Balkans either lived under Byzantium's direct rule, like the conquered Bulgarians, or vassalage, as was the case with the Serbs and Croats.

The conversion of the Slavs deserves a brief comment here. The Byzantines did not believe that God's Word required instruction in Greek or Latin, but that the Word of God must reach everyone in their own spoken language. In this vein, two Byzantine brothers from Salonika, Cyril and Methodius, set the foundations for an alphabet more suited to the Slavic language. In spite of the Byzantines' sense of superiority over other civilizations, they were more far-sighted than their Western brethren in their religious politics. They offered the liturgy to the Slavs in their own language, and this visionary approach provides part of the explanation as to why Orthodoxy planted such deep roots in the Slavs' souls.

By the death of Basil II, the foundations of a "Byzantine Commonwealth" had been set, and it forms the basis of the modern states of Greece, Bulgaria, Slav Macedonia, Serbia, and Romania. All were formed out of the common clay of Orthodox Christianity and Byzantine culture. While Byzantine civilization began to decline toward the close of

the tenth century, there was none more advanced or more enlightened in the European-Mediterranean world of its time. The complete ascendancy of the West Europeans would come later.

Enter Venice

When the barbarian hordes stormed over the Alps into Italy in the 400s, determined to decapitate the Western Roman Empire, some frightened townspeople and peasants took shelter on low, waterlogged islands near the mouth of the Po River, on the Adriatic Coast. Latin-speaking Romans, they eked out a precarious existence from the sea, and naturally looked to the Roman Emperor (that is what we would call the Byzantine Emperor) in Constantinople for succor. The Byzantine emperors provided imperial protection; and, as Byzantine subjects, the Venetians gained full access to the Empire's rich market. Quickly, the enterprising Venetians grew in wealth and naval power.

The symbiotic relationship between Byzantium and Venice would change due to geographical, political and religious factors, or more precisely, due to factors of religious politics. The Christian Church was one until the eleventh century, with slight differences in style and content between East and West. The Byzantine Patriarch in Constantinople gave the Pope in Rome deference as "first among equals" (*primus inter pares*), but beyond that, he was considered by his eastern fellow bishops to be a peer, nothing more. Religious competition developed between Rome and Constantinople in Eastern Europe for the Slavs' and Hungarians' souls resulting in success for both sides. However, Constantinople proved itself in the minds of most Slavs to be more flexible and liberal, resulting in their voluntary adherence to Constantinople.

Tensions between the Western and Eastern Churches reached the point where, in 1054, both Pope and Patriarch excommunicated each other. This unfortunate event between two politicians, albeit in the religious sphere, came at a bad time, and provided a religious justification for the further, complete, and nearly fatal division of Christendom.

Byzantium held several Italian enclaves in the south, where a Greek-speaking population loyal to Constantinople faced increasing pressure from Norman adventurers. The hardy, prolific, violent, and highly organized Normans, descendents of Viking immigrants to northern France, in addition to conquering England, had for years been streaming

southward, towards Italy. Their fighting skills unmatched at the time, they began swallowing up Byzantine cities in Italy until, in 1071, the last stronghold, Bari, fell to the Normans. Except for a brief period one hundred years later, Byzantine rule ceased on the Italian peninsula.

The Normans were not content with mere eviction. They crossed the Adriatic, laying waste to Byzantine Albania, and, following the Roman Via Egnatia, besieged and sacked Salonika, Byzantium's second city, in 1085.

Venice initially responded to Byzantine requests for naval assistance, but they too saw opportunities in a weak Byzantium. In our globalized electronic era, shifts of economic and political power happen so quickly it is often hard to realize they are occurring. A thousand years ago, shifts took much longer, but nonetheless remained palpable. In spite of their wealth and their sumptuous civilization, Byzantium was calcifying. As consummate seafarers, the Venetians were the most globalized and innovative people of their era, they sensed that Byzantium's powers were on the wane, and Western Europe's on the rise. When considering the religious angle after the separation of the Churches, along with their own geography in northern Italy, the Venetians thought it in their interest to side with the West.

With the Venetian turnabout, the shift of economic, and more importantly, naval and military power to the West was formidable, and Byzantium never regained its edge. Most unfortunately, however, these were not the only threats Byzantium faced. The same year that southern Italy fell to the Normans, the Byzantines suffered a crushing defeat in the east at the hands of the Seljuk Turks, at Manzikert in what is now the extreme east of Turkey, in 1071. Turks flowed into Asia Minor like water through a bursting dam, reaching the Sea of Marmara, opposite Constantinople, within ten short years.

Yet as serious as these setbacks were, Byzantium still had many cards to play. The empire was still rich, still had a strong navy, and its high culture began to have osmotic effects on the Turks, just as it had centuries previously on the Slavs. The key difference, however, was that the Turks had Islam, with its equally developed belief system. The Byzantine Emperor Alexius Komnenos decided that Western help was needed to push the Turks further into Asia Minor. The Emperor had hoped for mercenaries. Instead he got the Crusades.

From the beginning, the blood was bad between Crusaders and Byzantines. The experience of wave after wave of Western warriors and

monks passing through their lands widened the cultural and religious gap between Eastern and Western Christians, which, in due course, culminated in the sack of Constantinople in the Fourth Crusade of 1204. Venice masterminded the dismemberment of her former benefactor, and took as spoils strategic points from the Empire, some of which, such as Crete and Corfu, remained hers for half a millennium or more. The Byzantines managed to push the Crusaders out of Constantinople, Salonika, and Mystra, but various Western enclaves remained on former Byzantine lands for centuries.

Enter the Ottomans

While Byzantium was pushing out the Crusader states, they also gained ground in Asia Minor, holding the northwest of the peninsula, and all of the Western and Northern coasts. The empire, however, was a hollow shell of its past, in perpetual debt to Venice or Genoa, and its military capabilities no longer a match for the Western or Eastern armies it faced. The Turks regrouped under the dynamic Ottoman dynasty, and began chipping away at the Asia Minor and, eventually, the European possessions of the Empire. The Turks first settled on European soil in 1354, at Gallipoli, in Thrace. By 1389, they defeated the Serbian Empire, a Byzantine successor state that was the strongest in the Balkans at the time, at the Battle of Kosovo. In 1422, they besieged Constantinople for the first time.

The last fifty years of Byzantium merits the term "Greek Tragedy," as the dying empire produced art, philosophy, and ideas that prefigured the Renaissance. A cultural "Indian Summer" was followed by an attempt to re-conquer lost parts of Greece. The Despot of Mystra, Constantine Paleologos, who ended his days sword in hand as the last Byzantine Emperor, attempted to evict the Turks from Greece, and to establish a common front with the remains of the Serbian state. The Ottomans smashed these ephemeral efforts, and when Constantine's brother, the Byzantine Emperor John VIII died, in 1449, he accepted the crown of Byzantium. It is fortunate for Byzantium's thousand-year legacy that its last emperor acquitted himself with such honor.

Constantine's predecessors, and he himself, made every attempt to secure Western Catholic help to push back the Turks, but the price was always to submit to Papal control. Most emperors reluctantly were willing to do so, but at the same time the degree of assistance needed to push back

the Turks never materialized. Memories of the Crusades and Venetian usury were fresh, and many Byzantines espoused the dictum attributed to the last Prime Minister of the Byzantine Empire, Grand Duke Lukas Notaras, "Better the Turkish Turban than the Cardinal's Mitre!" In the final analysis, both Byzantine and Western Christian fought on the Walls of Constantinople against the Turkish siege of 1453 with honor. It is unfortunate that this cooperation was the exception, not the rule.

Constantinople's conqueror, Mehmet II, a man of exceptional intellect as well as savagery, sought to co-opt the defeated Byzantines' resentment of Western Christians for his own benefit. As the dust of conquest settled, Mehmet sought out the Byzantine monk Gennadios, staunchly opposed to union with the Catholic Church on Catholic terms. Assuming the role of the Byzantine Emperor, Sultan Mehmet invested Gennadios with the title of Patriarch, with control over all Byzantine Orthodox's spiritual and secular affairs. This appointment was the beginning of what one might call the Byzantine-Ottoman Social Contract, which preserved the Orthodox Church and community, but required subservience to Ottoman rule and higher taxes, including periodic "human taxes."

This "contract" reads like a bad bargain, and so it was. However, in the context of the times, it seemed the least bad of rotten alternatives. It preserved the Byzantine identity throughout the Balkan Orthodox, in suspended animation as it were, for a better day. The Turks *millet system* did not recognize ethno-linguistic divisions, only religious ones. As a result, religion became tied to ethnic identity even more so than in the Byzantine era. It remains so in the successor states of today. Hence the saying, "To be Greek is to be Orthodox."

The Byzantines were relatively docile in the first years of Ottoman rule. Turkish arms were unbeatable at the time, slicing through the Hungarian Plain and reaching the gates of Vienna by 1529. The Turks were cruel and capricious, and the blood tribute of children chilling, but in general the Byzantine populace was left relatively on its own. While this seems like a virtue and Turks of today point to this as evidence of the Ottomans' tolerance, it was also a vice. One of the Ottomans' greatest sins was that of civic neglect. Taxes were for the elite's consumption, for war, and for the adornment of a few mosques and monuments—but not for infrastructure or education. This neglect contrasted with what was emerging in the rest of Europe. Neighboring Austria and Venice, while not at all times the most enlightened of European states, nonetheless possessed increasingly professional and

honest bureaucracies, and investments in internal infrastructure, not the least education. The Turks' empire, especially as time went on, was characterized by corruption and capriciousness, and the thinness of civil society remains a key problem in all of the Balkan countries.

Enter Austria

Austria's successful defense of Vienna in 1683, accomplished with considerable Polish and other German assistance, marked the beginning of the Ottomans' long, tortuous decline. Within twenty years, the Turks had been pushed out of the Hungarian plain, to the gates of Belgrade. The Venetians seized the chance to regain possessions in Greece by an Austrian alliance, and Venetian troops, many of them German mercenaries or Greeks, swept the Turks out of the Peloponnesus, remaining there until 1715. On a hillside overlooking the Danube in 1699, in what would become the town of Sremski Karlovici, Venice, Poland, Austria, and the Ottoman Empire signed a peace treaty, where the Turks relinquished all of their Central European possessions and the Peloponnesus but kept their increasingly corrosive grip on the rest of Balkans.

The Austrians inherited a wasteland, ravaged by a century of warfare. Possessed of the Germanic flair for administration, the Austrians set to developing, and to defending, their new possessions. Catholic Germans from Swabia (hence the colloquial of *Shwabo* for local Germans in the Hungarian, Serbian, and Romanian languages) arrived to administer the region and to set up trades. Hungarians and Croatians regained from their demographic losses during the past two centuries of war. The Serbian presence that survived the wars in the area was bolstered by a large immigration of Serbs from the Ottoman Empire.

The Serbs struck a bargain unique in the history of Orthodox people under Catholic rule. They would immigrate and serve the Austrian Emperor as soldiers, settlers, and merchants, but only if their community and their religious rights were respected. Conscious of their need for good settlers and soldiers who had an axe to grind against the Turks, the Austrians accepted. These Austrian Serbs had the best of both worlds—their religion and culture respected in a dynamic socioeconomic environment that was in direct contrast to the static and deteriorating one found under the Ottomans.

By 1700, the Byzantines had been under Ottoman rule for the better part of 250 years. The Ottoman state provided the Byzantines with a

parallel, though inferior, community life intact. However, the descendants of Byzantium were basically stuck in the late Middle Ages at a time when their Western Catholic (and later Protestant) fellow Christians were in the full and rapid stages of cultural, educational and socioeconomic advancement. Clearly the Western economic and political models were in the ascendant, but the Turks steadfastly refused to open their society, perversely with the compliance and collusion of the Byzantine religious and social elites under their aegis.

More and more, their subjects in the former Byzantine lands started to vote with their feet—either to Russia, where Serbs, Bulgarians, and Greeks settled the lands around the north shore of the Black Sea, in an echo of the Serbs' settlement of Vojvodina, or to Western and Central Europe. Venice, Vienna, Trieste, Budapest, and points beyond also received Byzantine settlers, often involved in commerce with their relatives in the Ottoman Empire, as the Turks disdained commerce. So ubiquitous was the Byzantine merchant in Hungary that the word for Greek in Hungarian, *Gorog*, also colloquially meant "merchant."

The Dawn of "Freedom" of a sort . . .

The 1700s broke any lingering sense of legitimacy of Ottoman rule. The Byzantine peoples, particularly the Serbs and Greeks, had too many contacts with the West to ignore liberal thinking. The lingering mutual dislike between Western and Eastern Christian no longer remained the same barrier. Moreover, another champion rose to prominence—the Orthodox Russian Empire. As Russia gained in strength and marched inexorably south, many Byzantines looked on her as the ideal liberator, a successor state of Byzantium coming to liberate her enslaved brethren. As much as they immigrated west, far greater numbers of Byzantines, particularly Greeks and Bulgarians, settled in southern Russia. Russians encouraged the conquered Orthodox to revolt, particularly in Montenegro and the Peloponnesus.

As the 1700s drew to a close, the French and American Revolutions further stirred the imaginations of the Byzantine peoples. The French had fought both the Ottoman and Austrian Empires, and occupied the Ionian Islands and Dalmatia, bringing the soul of the revolution into the Balkans. The idea of usurping old calcified regimes and replacing them with nation-states began to take hold, even though the concept of nation,

as opposed to Byzantine restoration, took a while to take hold in the Balkans. It was most advanced among the Serbs, who had the advantage of a prosperous community in Austrian Vojvodina, contiguous to Serbia. The Greeks, too, were in the process of transforming their identity from *Romioi* (Byzantines) to *Hellenes* (Greeks), with an emphasis on the Classical Greece so beloved of Western Europeans. Greek and Serbian Diasporas also contributed to the rise in national identity back in the homelands, sponsoring schools and the spread of literature.

As national identities emerged from the Byzantine identity, there was also a sense of common religious identity throughout as Orthodox *Romioi*, bolstered further by common suffering under the Turks, who viewed all Orthodox, regardless of ethnicity, as the *Rum Milleti* (roughly translated as the "Roman Community"). No distinction was made for ethno-linguistic diversity. To some degree, this also mirrored the identity of the people, particularly in the central Balkans and Asia Minor. Their identity was as Orthodox subjects of the Ottoman Sultan. Realizing this, there was also a push for keeping the Ottoman Empire intact but returning the *Rum Milleti* as the ruling class—in effect, reconstituting Byzantium. Both the forces of nationalism and "Byzantinism" had adherents in every nation.

As it happened, the forces of nationalism prevailed against either a Byzantine identity, or the continuation under the old Austrian or Ottoman empires. The states that emerged all claimed descent from the Byzantine civilization, once was the envy of Christendom, but they operated on national criteria based on Orthodoxy, geography, and ethno-linguistic unity. To create these fictionalized states, other Orthodox within the borders of the states needed to be linguistically assimilated, and the non-Orthodox purged. Imported Western notions of state, ill suited to these emerging Medieval inhabitants, were used to foster this uniformity. Eventually, as the Ottoman Empire declined and dissolved, the Turks used Islam, the geography of Anatolia, and the Turkish language to coalesce a Turkish state in much the same way. In this manner, Turkey is eerily similar to the Orthodox states she held in thrall for five centuries.

All of these states, thus emerged, were traumatized orphans of empire, and all suffered from a sense of lost greatness, combined with a clear sense of inferiority vis-à-vis Western Europe and, later, the United States. They all were formed violently, experiencing massacres and large movements of refugees. From being the center of Western civilization, they had become the periphery.

Bibliography

Ascherson, Neal, *Black Sea* New York: Hill & Wang, 1995.

Clark, Bruce, *Twice a Stranger* London: Granta Books, 2006.

Fermor, Patrick Leigh, *Between the Woods and the Water* London: John Murray, 1986.

_____, *Mani: Travels in the Southern Peloponnesus* London: John Murray, 1958.

_____, *Roumeli: Travels in Northern Greece* London: John Murray, 1966.

Kaplan, Robert D., *Balkan Ghosts* New York: Picador, 2005.

_____, *Mediterranean Winter* New York: Random House, 2004.

Kazantzakis, Nikos, *Report to Greco* (Translated by P. A. Bien) New York: Simon & Schuster, 1965.

Koromila, Mariana, *Eutixismenos pou Ekana to Taksidi tou Odyssea*, Athens: Panorama, 1994.

Levinsohn, Florence Hamlish, *Belgrade: Among the Serbs* Chicago: Ivan R. Dee, 1994.

MacMillan, Margaret, *Paris 1919* New York: Random House, 2001.

Mazower, Mark, *Salonica: City of Ghosts* London: Harper Perennial, 2005.

Nicol, Donald M., *The Immortal Emperor* Cambridge: Cambridge University Press, 1992.

_____, *Byzantium and Venice* Cambridge: Cambridge University Press, 1988.

Pamuk, Orhan, *Istanbul* (Translated by Maureen Freely) New York: Alfred A. Knopf, 2005.

Runciman, Steven, *Lost Capital of Byzantium* London: Tauris & Co., 2009.

Stavrianos, L. S., *The Balkans since 1453* New York: New York University Press, 2000.

Seward, Desmond, and Mountgarret, Susan, *Byzantium: A Journey and a Guide* London: Harap Ltd., 1988.

Vojnovic, Milan, *Sombor: An Illustrated Chronicle* Sombor: Ines D.o.o., 2003.

Wheatcroft, Andrew, *Enemy at the Gate: Habsburgs, Ottomans, and the Battle for Europe* London: The Bodley Head, 2008.